Creative Inquiry

Creative Inquiry

From Ideation to Implementation

Mary Stewart

SUNY PRESS

Published by State University of New York Press, Albany

For information, contact State University of New York Press, Albany, NY
www.sunypress.edu

Library of Congress Cataloging-in-Publication Data

Name: Stewart, Mary, 1952– author.
Title: Creative inquiry : from ideation to implementation / Mary Stewart.
Description: Albany : State University of New York Press, [2021] | Includes
 bibliographical references and index.
Identifiers: LCCN 2021003251 | ISBN 9781438486123 (pbk. : alk. paper) | ISBN
 9781438486116 (ebook)
Subjects: LCSH: Creative ability. | Imagination.
Classification: LCC BF408 .S768 2021 | DDC 153.3/5—dc23
LC record available at https://lccn.loc.gov/2021003251

10 9 8 7 6 5 4 3 2 1

To Ken Baldauf

CONTENTS

PREFACE

Creative Inquiry: From Ideation to Implementation introduces both college undergraduates and general readers to the exploratory mindset and hands-on skills essential to the cultivation and implementation of new ideas. Using active learning, this book combines concise explanations and real-world examples with engaging exercises for readers to complete. The writing style is conversational, yet substantial, and the examples given reflect a wide range of disciplines, from early aeronautics and linguistics to zoology.

 Creative Inquiry: From Ideation to Implementation emphasizes the importance of direct experience, personal initiative and the generation of new knowledge. Step by step, the exercises build the skills students need when they tackle the final self-designed Capstone project. The expanded Introduction provides clear definitions of key terms and describes the book's structure, pedagogy and rationale. Three preliminary Warm-Up Exercises present the hands-on approach that is essential for creative development. The next four Creative Challenges are more extensive and offer solid background information along with a series of engaging exercises. Six ideation strategies follow. Readers are invited to explore convergent and divergent thinking, employ the power of analogies, investigate ways in which ideas can be transformed using different materials or new technologies, use associative thinking to create richer ideas, and utilize the power of pattern recognition. A partnership between creative and critical thinking is strongly emphasized throughout. As a result, Module 5 focuses on ways to choose and refine the best ideas.

 Positioned at the end of major sections, five brief self-reflection papers are designed to help students assess their progress and revise their assignments. To encourage collaboration and strengthen metacognition, teams of three to six participants work together on these papers. This encourages an iterative mindset and provides extensive writing practice. An Appendix provides a lively and practical "Top Ten List" of writing strategies for students who need extra advice.

 The book concludes with an extensive discussion of a final Capstone project and offers sample proposals from four disciplines: History, Art, Engineering and Computer Science. Every ambitious Capstone project runs into problems, and so a section on iteration follows, along with a section titled *Overcoming Obstacles*.

 Most ideation and critical thinking strategies can be applied successfully across many disciplines with just minor adjustments. Implementa-

tion is another matter. A computer science student who is developing a website needs very different instruction than a history student who is researching government actions during World War Two. Students from multiple disciplines who are taking multi-discipline Creative Inquiry courses often solve this problem by identifying a mentor or a Capstone advisor. To help demonstrate the role of creativity across disciplines, Module 7 offers seven interviews with innovators in business, city planning, medical engineering, interior architecture, literature, independent filmmaking, and social entrepreneurship.

Creative Inquiry: From Ideation to Implementation ends with a special section on internships. Developed jointly with Stephanie Vivorito (who was one of my outstanding interns at Florida State University), this section emphasizes ways in which internships can create a bridge between college coursework and employment. It includes down-to-earth advice on strategies for identifying and applying for internships and describes ways to maximize their value.

I am most grateful to my editor, Richard Carlin, who was receptive, wonderfully supportive, and amazingly prompt throughout the publication process. Insights by anonymous reviewers and Mathew Kelly resulted in more illustrations and a new section on systems thinking. Extensive recommendations by Sandra Reed at Marshall University and by Adam Kallish at Trope Collaborative greatly strengthened the pedagogy throughout. Designer Rachel Perrine created most of the graphics in the book and suggested the selfie project described on page 45. Stephanie Vivorito edited early drafts of this book and offered her insights and enthusiasm. Dr. T. Lynn Hogan, assistant provost at Florida State University, helped with the section on critical thinking. And, what a pleasure it was to interview this remarkable group of innovators: Mark Breen, Liz Canner, Ian Fogarty, Jeremy Thomas Gilmer, Christine Nieves, Jill Pable, and Emily Pritchard. They were all so generous with their time and their stories.

Finally, this book is dedicated to Ken Baldauf, director of the Innovation Hub at Florida State University. Over ten years in development, this amazing site offers inspiring coursework, technical advice, and an extensive maker-space to a wide range of users. Ken's knowledge, advice, support and enthusiasm seem boundless.

Thank you one and all!

Module 1

INTRODUCTION

A shared vocabulary is essential for effective communication. So, we must begin our journey by exploring the rationale for this book and defining several pivotal terms.

RATIONALE

Why Read This Book?

The reason to read this book is simple: it can help you develop ideas, solve problems, and pursue innovation. Ideation (the development of concepts) helps us to expand and refine our initial ideas. Implementation (the process of putting a plan into effect) helps us to turn our concepts and intentions into actions. This can result in innovation: the development of an improved product, process, or service.

There are many general-audience books that emphasize connections between ideation and innovation, but none offers the interdisciplinary and hands-on approach most beginners need. This workbook is designed to fill that gap. It is especially aimed at college undergraduates, yet it is sufficiently self-explanatory to be used by highly motivated readers outside of a classroom.

Perhaps you don't consider yourself to be a creative person, and you aren't sure you can develop new ideas. If so, you've been selling yourself short. Humans are naturally creative! Taking it step by step, you can discover unexpected abilities and realize hidden potential. Even if the exercises are unlike anything you have done before, they can help you expand your thinking and enrich your life.

What Are the Main Characteristics of Creativity?

Creativity provides us with the capacity to identify hidden possibilities in any situation and develop new connections. Rather than passively accept things as they are, the most creative people seek improvements and devise alternative courses of action. Whether they are composing music, inventing a new product, developing a business, or engaging in scientific research, the most creative people seem to see the world afresh every day.

Why Is Creativity Important?

Creativity drives scientific breakthroughs, sparks innovations in every conceivable field, and inspires social change. As a result, more and more businesses and nonprofits list creativity as one of their primary strengths. In response, coursework in entrepreneurship, innovation, creative inquiry, and design thinking is rapidly being added to curricula in universities and colleges worldwide.

How Does the Creative Process Work?

As shown in figure 1, creativity tends to shift from empathy, definition, and ideation to prototyping, testing, and critique. As we work our way forward, new opportunities as well as new obstacles appear. We often have to circle back to expand on an earlier step. Prototyping and testing are especially important. These steps turn abstract ideas into tangible objects and actions that can lead to crucial revisions.

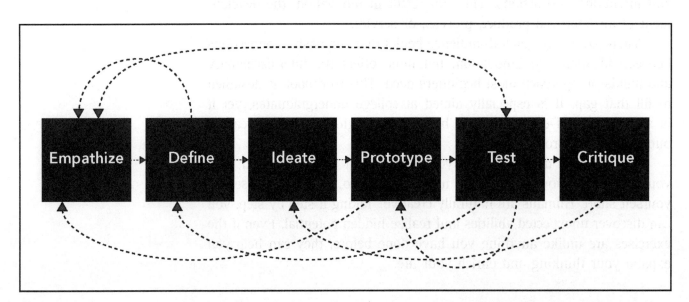

Figure 1. Design process. Forward movement is often interrupted by both setbacks and new insights. Source: Rachel Perrine and Mary Stewart.

In recognition of this one-step-forward-and-one-step-backward process, three premises will be reinforced throughout this book:

- The more ideas that we develop, the greater our chances of finding a great solution.

- By focusing on the most promising of our initial ideas and then developing them, we can avoid squandering time, money, and energy.

- A great idea never saved a bad solution. Even the cleverest idea is worthless if it doesn't really solve the problem.

What Is Creative Inquiry?

Creative inquiry is a problem-solving process that combines a wide range of ideation strategies with targeted research and purposeful critical thinking. Because creative inquiry emphasizes the development of compelling questions as well as the presentation of convincing answers, it encourages exploration, risk-taking, and independent thinking.

> **creative inquiry**
> is a problem-solving process that combines a wide range of ideation strategies with targeted research and purposeful critical thinking

Creative inquiry began as a premise, has evolved into a collaborative teaching and learning process, and is now stimulating wider exploration of ideas and their implications across many disciplines. More volatile than traditional university coursework, it can take many different forms, depending on the teacher, the students, and the institutional context. In all cases, though, creative and critical thinking work together to advance viable solutions to significant problems.

Why Complete the Exercises in This Book?

Creative inquiry requires personal initiative and is best developed through active learning. The readings in this book make a lot more sense when they are connected to the exercises. This calls to mind an old proverb: "I hear, and I forget; I see, and I remember; I do, and I understand." By doing the exercises, you can apply the book's content to your own life.

ORGANIZATION

What Are the Eight Modules?

Creative Inquiry: From Ideation to Implementation is organized into eight modules. This introduction provides the rationale for this book, its orga-

nization, and its essential terminology. In module 2, three short warm-up exercises provide a lively introduction to the hands-on working method we will use. In module 3, the ideas you develop through these exercises are expanded through four creative challenges. In this section, we will focus on understanding user needs, incremental and transformative change, the importance of clear problem definition, and the value of targeted research. An extensive discussion of idea-generation strategies (module 4) and idea-selection strategies (module 5) follows. Creativity requires exuberant ideation; implementation requires careful selection and practical action. Because both are so important, modules 4 and 5 are especially robust. Their exercises set the stage for module 6: a capstone project. This project gives you a chance to define a problem of personal significance and then to design a solution. Module 7 consists of seven interviews called innovator insights. These can help you understand the ideas that have inspired innovations and the obstacles that entrepreneurs have overcome. The concluding eighth module includes a special section on internships, which provides practical advice to readers seeking hands-on experience and a potential career springboard. This book ends with practical advice on writing, a glossary, and examples of further resources.

Whose Stories Will Be Told?

The interviews focus on the achievements of inventive people who have done extraordinary things. In this book, you will meet

- an entrepreneurship mentor who has helped to redesign numerous Canadian businesses,

- a scientist and educator who emphasizes problem solving in his teaching,

- a biomedical engineer whose inventions transform patients' lives,

- an engineering project manager and writer who uses creativity in both disciplines,

- an interior designer committed to improving housing for homeless populations,

- an independent filmmaker whose projects publicize social problems and solutions, and

- an entrepreneur who is working to connect leadership, education, and community in Puerto Rico.

Each interview ends with engaging and encouraging down-to-earth advice.

What Strategies Will You Learn?

Upon successful completion of the exercises in this book, you should be able to

- use research as an essential aspect of innovation,

- identify connections between creative and critical thinking,

- develop and utilize multiple ideation techniques,

- improve an initial idea through multiple iterations,

- clearly identify and overcome obstacles, and

- begin to connect your coursework to your career.

How Can You Apply These Skills?

Truly creative people develop a strong capacity for thinking outside the box. To increase your self-motivation and encourage independent thinking, all of the exercises in this book are designed to help you develop the skills you need to pursue a self-designed project that is personally significant. As a preview, a concise outline for this project follows. The expanded description begins on page 56.

By understanding the overall direction of this book, you can begin collecting ideas and identifying resources at any time. Being on the lookout for potential mentors or collaborators is especially important. Someone almost certainly knows more than you about the research you plan to pursue. Talking with that person can help you focus and move forward. Maintaining a small notebook with your ideas and potential resources will help you keep your notes organized and active.

CONCISE CAPSTONE PROJECT OUTLINE

Title: Give your project a descriptive and memorable title. You want it to stand out, and the title itself can help define your intentions.

Investigator(s): Who will complete the work—a single person or a team?

Problem Description: What will you do?

Significance: Why is it important?

Audience and Users: Who will gain from the result?

Potential Supporters: Students are surrounded by helpful people, including instructors, other students, advisors, and possibly a college leadership center or technical assistants in a lab. Successful entrepreneurs seek out venture capitalists and value their advice as much as their money. What might any (or all) of these folks contribute to your project?

Targeted Research Questions: What more do you need to know about this problem in order to reach an effective solution?

Research Resources: What books, videos, workshops, websites, or other resources can help you solve your problem?

Ideation and Selection Strategies to Use: You will develop ideation strategies through the exercises in this book. Which ones are most likely to be helpful here?

Potential Obstacles: What obstacles do you anticipate upfront?

Criteria for Success: In your mind, what would constitute success?

Projected Timetable: What do you plan to accomplish each week?

TERMINOLOGY

What Terminology Will We Use?

For clarity, let's now define a few key words that inform the subtitle, *From Ideation to Implementation*. (Boldfaced terms are also included in the glossary.)

DEFINING IDEATION

ideation
the process of developing ideas and forming concepts

Ideation can be defined as the process of developing ideas and forming concepts. Three main words in our ideation definition are also significant. So, let's consider definitions for *process, concept,* and *form,* and why they are important.

UNDERSTANDING PROCESS

Process can be defined as a series of actions taken in order to achieve a particular end. Through a creative process, we can develop both our ideas and ourselves over time.

Why Is This Important?

Great ideas rarely burst forth clearly defined and fully formed. In fact, the more innovative the idea, the rougher it may be, at least initially. If no one has ever tried the amazing approach you propose, you will probably have to make a lot of mistakes before determining the best way forward. As a result, our ideas typically evolve through a series of versions known as **iterations.** Ideally, each iteration improves on the previous one until a satisfactory solution finally emerges.

This book is based on the premise that creativity is a human characteristic that anyone can cultivate through sustained effort. As a result, the self-reflections offered at the end of each major block of work encourage you to revisit and revise your initial ideas. Forget about the quick fix or simple talent. Both our creativity and our ideas tend to develop through iteration rather than through wishful thinking.

DESCRIBING CONCEPT

Concept (our next ideation key word) is complex and requires more explanation. Concepts tend to be broader and more abstract than ideas. For example, "When it comes to food, everyone should be self-sufficient" is a concept. "Let's grow a garden this summer" is an idea.

A concept may seem simple at first. For example, the basic concept behind the cell phone is this: in communication, mobility is an advantage. Because old-fashioned phones were anchored to buildings, the user had to go *to* the phone in order to make a call. Today, every user carries a cell phone. As we now know, this enables constant communication and offers all sorts of everyday uses, from GPS to social media and beyond. The mass-marketed cell phone now seems inevitable—but it was revolutionary when introduced in 2007.

Because concepts tend to be broad and abstract, they invite extensive investigation. *Time* is an example. We may begin at a basic level, with simple distinctions among past, present, and future events: "We went to the grocery store, we are buying four apples, and we will eat the apples tomorrow." Things get more complicated as soon as we add memory of the past and plans for the future: "As we ate the apples, we remembered

the time we picked fruit at my uncle's farm. Let's do that again next summer." Time becomes more complex still when we consider ways in which it can compress or expand depending on context. For example, two hours at a dentist's office may seem endless, while two hours watching a well-edited movie just fly by. And for a physicist, historian, epidemiologist, or paleontologist, time becomes even more meaningful and complex. In all cases, though, the concept of *time* drives our investigation, whether we tackle it at a very practical or more theoretical level.

DEVELOPING FORM

Form, the final component in our definition of *ideation,* creates a bridge between the words *process* and *concept.* Form can be defined as the tangible manifestation of an idea. An architectural idea takes form when a building is constructed; a political idea takes form when a campaign is launched or a law is passed; a cake is formed when flour, eggs, and other ingredients are combined and baked. Through form, our concepts shift from general intentions into tangible objects and actions.

DEFINING IMPLEMENTATION

implementation
the process of putting a plan into effect

This leads us to *implementation*, the last word in the book's subtitle. As noted at the beginning, **implementation** can be defined as the process of putting a plan into effect. Because truly innovative concepts are very difficult to implement, having a great idea is only half the battle. Implementation requires just as much skill as ideation does—and usually, a lot more fortitude and money! As a result, various aspects of implementation are discussed throughout this book:

- understanding user needs

- defining problems clearly to produce effective results

- researching existing solutions and understanding their strengths and weaknesses

- selecting the most promising option from a range of possibilities

- identifying hidden potential and overcoming obstacles

The ideation strategies in this book can be applied to any discipline. However, the actions we take and the obstacles we encounter become more discipline specific when we move toward implementation. To provide

examples of creativity in various disciplines, the interviews starting on page 75 offer personal stories from very different perspectives.

What Is the Role of Design Thinking?

Many of the exercises in this book are inspired by **design thinking**, a sequence of practices that helps people innovate effectively, especially in business. This methodology combines empathy, logic, imagination, intuition, and systematic reasoning to explore a wide range of possibilities and then develop the best to produce something new.

As a broadly based entry-level book, *Creative Inquiry* references design thinking practices while remaining readily accessible to all readers. Regardless of our disciplines, we can all benefit from a greater capacity for ideation and a deeper understanding of implementation. Those seeking degrees in engineering, design, or business often expand on this introduction through more extensive coursework in design thinking, management, systems design, and human-centered design.

Module 2

WARM-UP EXERCISES

WARM-UP 1: USING CURIOSITY TO SPARK NEW IDEAS

Why Is the Current Design Used? Would Another Design Better Serve Likely Users?

Rationale: Simple curiosity can drive two essential questions. By looking around your room, you can easily toggle between these questions: Why? and What if?

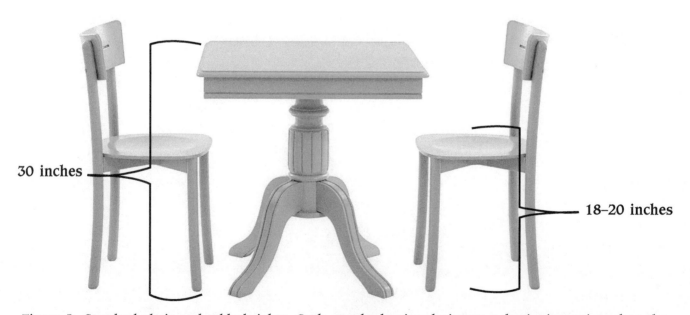

30 inches

18–20 inches

Figure 2. Standard chair and table heights. Such standards give designers a beginning point when they are developing functional objects. Source: Shutterstock.

Real-World Example: The heights of a dining room table and chair tend to fit a basic pattern. Thirty inches is a standard table height in North America, and the seat of the chair is usually around eighteen to twenty inches high (figure 2). In this case, the Why? seems pretty straightforward. Based on an average adult height of sixty-seven inches, these standard dimensions should accommodate most North American adults comfortably.

But this conclusion can quickly generate a What if? question. What if the user is a child or a nonstandard adult? Taking it further, what if the heights of the table and chair could be adjusted to better suit people of different sizes? Such adjustments would be more difficult to design and build, but wouldn't the resulting versatility be worth it?

This leads us to the last question for this first exercise. Who are the likely users? If the furniture will be used in a college dining hall, it may be more effective to provide several tables that are designed to accommodate wheelchair users and their friends while retaining a standard configuration for the rest of the space. The extra cost, complexity, and failure rate of adjustable furniture may make more sense if the entire space is occupied by a wide range of users.

DO THIS: Select a musical instrument, a piece of sports equipment, a fairly complex recipe, a basic hardware-store item, or an item of clothing—something you can physically handle or can eat. We will work with this selected object in several exercises, so consider at least five possibilities before making your choice. Write a two-hundred- to five-hundred-word commentary, exploring how and why it is used and by whom. This may initially seem obvious—but try to dig a bit deeper. A birthday cake is more than a sweet treat; it is a way to celebrate a life. As a result, the cake given to a small girl may be very different from the cake presented at the birthday of an elderly man. Then, discuss your results in teams of three to six people. The best teams will include a wide range of people and a variety of solutions to discuss, so seek out folks you don't already know!

Note: Careful observation and empathy are essential ideation skills. This exercise introduces both. A handheld object or a pot of chili requires us to consider user needs very directly. What is the size and shape of the object? Is it durable and easy to use? How spicy should the chili be? Is there a vegan option? Can our likely users afford the object or the food we provide?

WARM-UP 2: IDENTIFYING THE VARIABLES

What Range of Variables Need We Consider When Seeking a Problem Solution? What Characteristic Must the Service or Product Retain, and What Characteristics Can Vary?

Rationale: By researching an existing object and considering the range of existing variations, we can greatly expand our understanding of both the criteria for success and the range of existing solutions possible.

Real-World Example: Examine an adhesive bandage and consider the times that you have used one. Then, review the following questions and answers:

- *Who made the first Band-Aid?* Earle Dickson, a cotton buyer at the Johnson & Johnson Company, developed the Band-Aid in 1920. He wanted to help his wife, who often cut her fingers while cooking.[1]

- *What problem does it solve?* A Band-Aid covers a small wound and provides the temporary protection needed to promote healing.

- *How was it first made?* Dickinson combined adhesive tape, gauze, and crinoline fabric in his design. His wife could then apply the bandage herself and the crinoline kept the bandage from sticking to the wound.

- *How are adhesive bandages similar and how are they different?* Variations on the original invention are now offered by many companies and in many sizes, shapes, and colors. All combine a sterile pad with an adhesive strip. Some include an antibiotic in the pad; others are waterproof.

- *What do all of the successful solutions have in common?* Each successful solution solves the basic problem: temporary wound protection using an adhesive strip that adheres to the skin but doesn't cause damage when it is removed. All of the bandages are inexpensive and a new one can be applied daily, if necessary.

DO THIS: Now, return to your selected object from the exercise in warm-up 1. Building on your initial research, create a list of questions and answers that are similar to those in the bandage example. Especially note the range of possible variables—what characteristic must the object

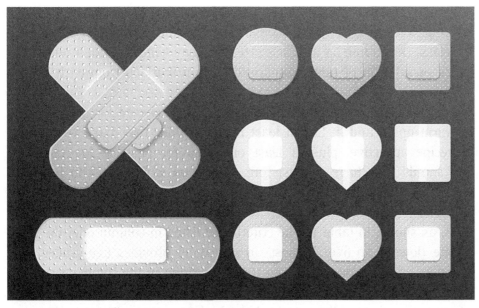

Figure 3. Adhesive bandage variations. Dozens of types are now produced by various manufacturers. Source: Shutterstock.

or recipe retain, and what characteristics can vary? How wide is the range of possible variations?

Note: Analyzing existing products and then considering potential alternatives are essential creative habits. The existing and possible solutions are often more varied (and weirder) than we might expect!

WARM-UP 3: ESTABLISHING THE CRITERIA FOR SUCCESS

On What Basis Should an Innovation Be Judged?

Rationale: Creative and critical thinking go hand in hand. **Creative thinking** helps us to identify opportunities and develop potential solutions; **critical thinking** helps us to choose the best solution from a range of options. How can we differentiate weak solutions from strong ones? To make the right choice, we need to understand our criteria for success. This exercise begins with a playful group activity that is followed by further analysis of the object selected in warm-up 1.

Group Play: Consider a favorite beverage (a cup of coffee, a glass of juice, a bottle of seltzer) or a favorite snack. List four to six qualities that make this your favorite. In addition to taste, crunch, or nutritional value, consider its availability, cost, and any other quality that you find

Creative thinking helps us to identify opportunities and develop potential solutions

critical thinking helps us to choose the best solution from a range of options.

attractive. Discuss your results with three to six peers, then select the beverage or snack the group considers best, and offer small samples to the class. Depending on the class size, you may wind up with a refreshing snack or a buffet of treats comprised of contributions from each team!

Then, DO THIS: Return to the first object you selected for the exercises in warm-ups 1 and 2. List at least three qualities that make your object or recipe attractive, plus at least one area for possible improvement. You should now have at least four criteria on which you can judge its strength or weakness.

These criteria can be used to create a simple **rubric** (assessment tool), as shown in table 1. The criteria are listed in column one; the scale of one (lowest) to five (highest) in the center provides five grades. The rationale for your judgement can then be written in the comment section. In this example, I've created a rubric for adhesive bandages. Adhesion, protection, and durability received the highest ratings. The criterion that received the lowest rating was skin color. A child might enjoy a bandage that is decorated with a superhero image, but adults might prefer an option that is closer to their skin tone.

Table 1. Bandage rubric. A rubric provides a simple way to clearly assess the strengths and weaknesses in an object or idea

CRITERIA	1	2	3	4	5	COMMENTS
Effectively adheres to skin			x			Very good, except on fingers and toes
Effectively protects wound				x		Excellent
Is easy to attach		x				Difficult to attach to curved surface
Is easy to remove		x				Can be too adhesive, damaging skin
Is durable—will last at least one day				x		Generally lasts for one day
Is attractive to adults and children	x					Many options for children. Few options for diverse skin colors.

Finish the exercise with a concise written summary, briefly describing the rationale for the criteria you selected and how these criteria could help to improve your object or recipe.

Note: Identifying and then applying appropriate criteria for success makes it easier for us to select the best option from a range of possibilities. Without this capability, we can become paralyzed by endless alternatives. Overlooking unrealized potential is equally destructive. Truly

innovative ideas are rarely polished and ready to implement right away. By clearly identifying both the weaknesses *and* strengths in our work, we can move forward more intelligently.

Self-Reflection 1: Warm-Up Exercises

Rationale: Periodic analysis of your assignments can help you see the progress you are making and identify the areas in which you need more practice. This type of self-assessment can help feed independence, which in turn helps fuel an entrepreneurial mindset.

DO THIS: Discuss with at least three other students the rationale for the three exercises you have just completed, plus the criteria for success in each. What was the point of each exercise? Did you take every exercise as far as you could? Now that you see how they all fit together, are there any improvements you can make in your ideas or your writing? If you struggle with writing, read the appendix, "Ten Easy Ways to Strengthen Your Writing," on page 112, and if one is available, work with your college writing center. Both resources can help you turn good ideas into great writing.

Making a simple rubric for each assignment can strengthen your analysis. Then, exchange your three exercises with two other students and receive their work in return. Using the criteria for success you have identified as a group, mark up your friends' exercises so that they can revise the entire project and ultimately submit outstanding results. Ideally, each team member's work will improve, thanks to this review.

Note: Three aspects of effective ideation are embedded in this assignment. First, you are invited to analyze the criteria for success for each assignment. Second, by working together as a team, you are gently introduced to a type of collaborative thinking that tends to be targeted and highly productive. Third, you are strongly encouraged to revise your work. This encourages active learning and demonstrates the power of revision. Try, try again!

Module 3

CREATIVE CHALLENGES

We are now ready to move on to a series of more demanding creative challenges. More background information is provided in each case, and the assignments are more demanding.

CHALLENGE 1: UNDERSTANDING USER NEEDS

Which Users Are Likely to Use My Invention?
What Do They Need? How Can I Provide It?

Rationale: Understanding user needs is essential. A complicated invention that is expensive or hard to use is generally less valuable than a modest invention that is easy to use and economical to produce. And a product or service that doesn't really help its users has no value at all.

A Real-World Example: Mechanical engineer Dr. Amos Winter teaches at MIT, directs the Global Engineering and Research (GEAR) lab, and is a cofounder of Global Research Innovation and Technology (GRIT). He learned that over forty million people in third-world countries needed wheelchairs that they could power themselves over extremely varied terrain, including dirt roads and grassy fields. Furthermore, to be really useful, the wheelchairs had to be inexpensive to produce and easy to repair.[2]

The gearing system on a mountain bike initially seemed like a possible solution to fill this need. The bikes were user powered, sturdy, and effective in many types of terrain. However, their chain-linked system was too complex to manufacture or repair in rural communities.

So, Professor Winter and a team of MIT students designed a chair (figure 4) that allowed users to shift gears and power the chair using sturdy metal levers. When he tested the first version with users in East Africa, he found that the seat position was awkward, and the levers

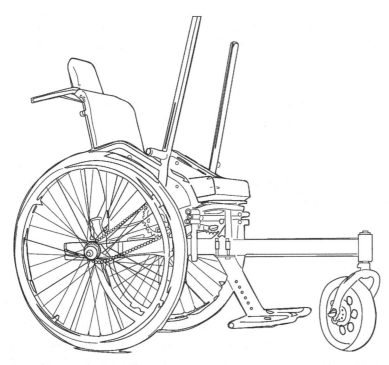

Figure 4. Amos Winter and team, Leveraged Freedom Chair. Drawing by Rachel Perrine. This innovative design combines simplicity, economy, and versatility. Source: Rachel Perrine.

needed to be easier to use. The next design was too heavy and bulky for use indoors.

Seeking the strongest, lightest, and most economical wheelchair possible, Professor Winter got additional input from manufacturers and users. He and his team then developed a wheelchair that met four essential criteria. It cost less than $200; could travel up to three and a half miles a day; was easy to manufacture and repair; and, when the levers were removed, could act like a standard wheelchair. This made it work well indoors. By understanding user needs and creating a simple and elegant solution, Winter and his team transformed wheelchair design and laid the groundwork for a new business.

DO THIS: Building on your experience with the initial warm-up exercises, look around you—at mechanical devices, children's books, city parks, architectural spaces, and websites. Select a common object or a website that is either beautifully designed or very badly designed. Write a two-hundred- to six-hundred-word paper considering

- who the object's primary users are,

- what their primary needs are, and

- how the chosen object meets (or does not meet) their needs.

As shown in the warm-up 3 exercise, a simple rubric can help with your analysis. Review that exercise and create a rubric if that will help you move forward.

Note: A service or product developed without user input rarely meets user needs. This seems pretty obvious—and yet remains a common problem with innovations of all kinds.

CHALLENGE 2: INCREMENTAL AND TRANSFORMATIVE

*Both Improvement and from-the-Ground-Up Invention
Can Result in Innovation*

Rationale: Dissatisfaction with an existing product, service, or system has driven the redevelopment of all sorts of things, from coffee makers and social-media platforms to laws and political parties. Frequently, these improvements are driven by existing users who are frustrated and seek a better way forward through *incremental* (gradual) change.

Transformative change occurs when an innovator identifies a problem that hasn't already been solved or pushes an existing product, service, or system so far that something quite new emerges. The smartphone is an example. The inventors certainly built upon technologies used in existing mobile devices, but the iPhone and other such devices provided so many new capabilities that they radically transformed daily life.

Both incremental and transformative change require creativity. So, in this challenge, you can choose between improving something that already exists or inventing something that is substantially different. Both options use curriculum design as a springboard for action. How can you revise an existing course or create a brand-new program?

To maximize the room for invention, you will be developing curricula for Utopia University, an imaginary institution with highly motivated students and inventive professors. Fortunately, Utopia University has vast resources; if you need to bring in Bill Gates as a guest speaker or want to serve dinner to eighty guests, you can do so!

DO THIS (Option 1): Hopefully, you are pretty excited about your college major; now you can share that excitement with others. Using the format shown in table 2, devise a course that will attract nonmajors to your discipline and inform them of its essential concepts and processes. This approach lays out a brief course description, and then lists

objectives (what students can learn from each assignment), assignments (described briefly), and resources (readings, videos, and podcasts that help to advance learning). When she was a student, Hannah Wier wrote a sample syllabus for an invented Art History class.

OPTION 1 EXAMPLE

Introduction to Art History–Utopia University ARH2000,
by Hannah Wier

This course provides a brief survey of art history and teaches students how to view, understand, and write about art in various ways. Lectures, activities, and readings will be combined to form an immersive look into the world of art history and the basics of art interpretation.

Table 2. Art history proposal for Utopia University, by Hannah Wier. This chart lays out topics, assignments, and resources

OBJECTIVE	ASSIGNMENTS	RESOURCES
Develop a general knowledge of art history and the change in purpose of art over time.	*One Word*—Students will be given a list of artistic movements/periods covered in the class lecture and asked to label each movement with up to three words that suggest or explain the essence of the movement. *Favorite Movements*—Students will complete a discussion board post, briefly describing their three favorite art movements and an artist who exemplifies each movement.	Chapters 16 through 20 in *A World of Art* by Sayre Chapters 2 and 3 in *Living with Art* by Getlein
Learn and apply the "language of art" to the description of art.	*Rapid Description*—Ten images will be projected in class for thirty seconds each, and students will quickly describe each artwork using any terms learned so far. *Composition and Content*—Students choose any artwork seen in weeks 1 or 2 and write a 150–200-word description of connections between its content and its composition.	Chapter 2 in *A World of Art* by Sayre Chapters 4 and 5 in *Living with Art* by Getlein

continued on next page

Table 2. Continued

OBJECTIVE	ASSIGNMENTS	RESOURCES
Employ critical thinking and an understanding of the process and function of art criticism in writing a critique.	*Art Critic for a Day*—Students will write a brief critique of the artwork from the previous assignment. (*Composition and Content*) or another artwork of the student's choosing. What are its strengths and weaknesses?	Pages 1–5 in *A Short Guide to Writing About Art* by Barnet Pages 141–147 in *A Short Guide to Writing About Art* by Barnet
Gain an appreciation for art in its various forms through independent study.	*Synthesis*—Students will put all of their art-history-focused writing skills together to write a one-thousand-word paper that includes a formal analysis and critique of artwork. The student MUST see this artwork in person on a museum or gallery visit.	BBC, "Why museums are the new churches" http://www.bbc.com/culture/story/20150716-why-museums-are-the-new-churches

Or **DO THIS (Option 2):** For a more transformative approach, you can invent a new certificate program comprised of at least five courses. Certificates are often created for interdisciplinary or internship-based programs that don't fit within a traditional academic format. For example, a certificate in college leadership might combine courses in education, management, and entrepreneurship. Looking up examples of actual certificate programs online will provide you with plenty of real-world examples.

Through this challenge, try to really push the possibilities for invention, so that you devise a distinctive program that goes well beyond a conventional major. Start by thinking about interdisciplinary connections that could be made through your program or about opportunities to connect the students' college coursework to their professional aspirations. Then organize the courses into a simple scope-and-sequence chart (table 3).

Table 3. Scope-and-sequence chart, blank template

Students Will Gain	Course 1	Course 2	Course 3	Course 4	Course 5

In this structure, you identify at least four things you want students to gain, and then identify the courses or internships in which that content will be presented. While the content may be distributed over five or more courses, some skills are usually emphasized in one course while other skills are emphasized in another.

One advantage to a scope-and-sequence chart is that you can see at a glance the key skills that will be taught. In table 4, I've bolded the section on critical-thinking skills, to help emphasize their importance on my sample curriculum. They are taught and developed in every single course.

Your completed assignment should include such a chart plus brief descriptions of each course, as shown in the following section.

OPTION 2 EXAMPLE

INTERDISCIPLINARY INNOVATION CERTIFICATE

Designed for sophomores, juniors, and seniors, this certificate helps students expand their creative capabilities and build a stronger understanding of multiple connections between their courses.

COURSES

Creating Connections (three-credit course) focuses on connections of all kinds: between past and present, between what is known and what is speculative, between emotions and actions, between people and governments. Various visualization strategies will be used to help map out connections and their consequences.

Design Thinking (three-credit course) provides a hands-on approach to problem seeking and problem solving and includes an internship with a local nonprofit organization. This course will focus on empathy, idea expansion and organization, implementation strategies, and social responsibility.

Agility and Adaption (three-credit course) explores survival techniques in various organizations and in nature. Field trips to a biology lab, a nature preserve, and an advertising agency help to make the ideas more tangible.

Impactful Decision Making (three-credit course) explores techniques developed by various national militaries in making life-and-death decisions. Guest speakers will provide real-world stories of choices and consequences.

Leading Change (three-credit course) defines leadership, presents a range of common leadership mistakes and strategies, and provides direct experience in leading a collaborative team.

All courses will combine lectures, labs, and field trips and will extensively use online resources.

Table 4. Sample scope-and-sequence chart for a certificate program

Students Will Gain	IIC 101 Creating Connections	IIC 102 Design Thinking	IIC 103 Agility and Adaption	IIC 104 Impactful Decision Making	IIC 105 Leading Change
ability to describe historical, political, and ecological context of a decision	X		X	X	X
capacity for combining analysis with synthesis		X	X	X	X
ability to engage in multiple problem-solving processes		X	X	X	X
improved communication and time-management skills	X	X			X
expanded understanding of critical thinking	X	X	X	X	X

CHALLENGE 3: PROBLEM DEFINITION

Identifying and Clearly Defining a Problem that You Really Want to Solve Strengthens Results

Rationale: Instead of simply solving problems presented by others, the most creative people identify, define, and propose solutions to problems that they devise themselves. Even when working on a problem presented by a client, a designer must often reframe a vague or misguided question before pursuing the answer. In this challenge, you will list a range of problems that can best engage or expand your capabilities, select one, and then begin developing a problem description.

Problem Seeking: Consider these three questions. What problems have been solved, and what problems remain to be solved? What problems do you most want to solve? Why? Let's consider three examples.

Dr. Kristine Harper is a historian with a particular commitment to the history of science. When seeking a new research topic, she often looks for anomalies and unanswered questions. Noticing gaps in the literature on a given subject may be crucial, especially when the topic is politically sensitive. Has evidence been suppressed?

Dr. Karen McGinnis is a biologist. Gene sequencing in plant DNA is her primary area of research. She reviews her past work and considers the research that other biologists are conducting and reporting worldwide. She then identifies questions that can further add to our understanding of DNA. For McGinnis, DNA research is like a tree of knowledge. She must identify the existing branches before adding a new leaf to the tree.

Dr. Pat Villeneuve is an arts administrator who focuses primarily on museums and their educational programs. She is especially interested in identifying significant social questions and telling compelling stories through art. Where are the untold stories or the artists who have been overlooked? Through an exhibition, how can her various audiences explore new ideas and gain new insights?

Essential Aspects of Problem Definition. A well-designed problem is like a well-designed assignment in a college course. Both share the following features:

- *Responsive to existing needs.* As the Leveraged Freedom Chair (figure 4) demonstrates, a solution that really fulfills user needs can transform lives. The first model was difficult for users to power and steer. The final design evolved substantially on the basis of user input.

- *Sufficiently open to encourage experimentation.* Problems that are too tightly defined limit creativity. There must be plenty of room for investigation and experimentation.

- *Sufficiently narrow to focus attention.* The most creative people can generate alternative solutions endlessly. While invention of this kind can be valuable, the capacity to focus and reach a conclusion is equally important.

- *Authentic.* Each of us has a unique perspective; thus, we each see the world differently.

Problems we really care about spark our imagination and increase our motivation.

Real-World Example: As a textbook writer, my editors and I devote a lot of time to problem definition. No publisher will sign a contract for a

book that seems aimless or for which there is no market. For example, in developing a proposal for a recent book on creativity, I wrote a prospectus that laid out my plans quite clearly. It included the following description, list of distinguishing features, and reader benefits:

TITLE: *Applied Creativity: An Interdisciplinary Introduction*

DESCRIPTION: *Applied Creativity* is designed to introduce both college undergraduates and a general audience to a wide range of interdisciplinary perspectives on creativity. Its projected length comprises nine chapters: 280 pages with forty images. One-paragraph descriptions of at least three real-world problems and their solutions will set the stage in each chapter. Three in-depth case studies follow, providing more extensive success stories and down-to-earth recommendations.

COMPETING TEXTS: Heightened interest in creativity and innovation has resulted in an explosion of general-audience publications in the past five years. The resulting books typically appear in self-help, psychology, education, and business bookstore sections. Among the best are *A More Beautiful Question*, by Warren Berger, *Sparks of Genius*, by Robert and Michele Root-Bernstein, *inGenius*, by Tina Seelig, *The Startup Playbook*, by David S. Kidder, *The Creative Habit*, by Twyla Tharp, and *The Art of Innovation*, by Tom and David Kelley. All of these examples are accessible, informative, and, to some extent, practical. *Applied Creativity* will build on these positive characteristics and offer a concise introduction that is designed for college undergraduates.

PRIMARY QUESTIONS THIS BOOK WILL ADDRESS INCLUDE THE FOLLOWING:
- How can dissatisfaction with the status quo fuel creativity?
- How can students best identify and most clearly define a problem to solve?
- What is ideation, and how can it be used most productively? What is iteration, and how can it strengthen and enhance ideation?
- How does critical thinking expand creative thinking?
- What need students know about past or present solutions to similar problems? How can this research be conducted most effectively?
- How can people with diverse perspectives strengthen an organization or business? How can ideas from various disciplines be combined to create fresh results?
- What are the advantages of traditional training or education in a specific field? What are the advantages of pursuing unfamiliar or varied lines of inquiry?
- How can a preliminary project serve as a professional springboard? How can an initial idea be developed into a major initiative or influence an entire industry?

READER BENEFITS: Applied creativity now informs every discipline and affects every business in our fast-paced world. This book is designed to provide an engaging, informative, and highly accessible introduction to idea generation and implementation in any discipline. By increasing their capacity for creative thinking and effective action, readers can enhance their professional possibilities and effectively act as catalysts for change.

A prospectus needs to balance specificity with brevity. The description must be thorough, yet concise. No busy editor has the time (or patience) to read rambling or long-winded text!

DO THIS: Make a list of at least four products or services you might revise or invent. Then select the two that seem most promising and answer three questions about each of them:

- What is most interesting about this product or service?

- What is most significant about this product or service?

- What can I gain by developing this product or service?

Then, using a format similar to that used in the *Applied Creativity* textbook proposal, write a three-hundred- to five-hundred-word description of the one you most want to develop. Be sure to list existing products or services and then describe the advantages your version or invention offers.

Note: While it may seem tedious, writing a description of this kind helps us clarify our intentions and understand our motivations. Because our first idea is rarely the best idea, spreading this assignment over several days can really help. This provides time for reflection and revision.

CHALLENGE 4: TARGETED RESEARCH

Understanding More about Your Subject Can Further Strengthen Your Problem Definition

Rationale: As we further explore ideation and implementation, we often find that we need to conduct extensive research. We need to know as much as possible about existing solutions to similar problems, understand previous failures, and simply dig more deeply into the questions we need to answer. So, in this challenge we will use targeted research to elaborate on the proposal developed in challenge 3.

DO THIS: Carefully review the diagram in figure 5. It provides a series of targeted research questions that might be used by an exhibition curator (such as Dr. Villeneuve) if she were researching an African mask, Chinese vase, or other art object. Then, develop a similar chart that lays out the questions *you* need answered. Build a list of possibilities and questions to address, and then, answer the questions as fully as you can. Add your results to your challenge 3 draft so that they can be submitted together.

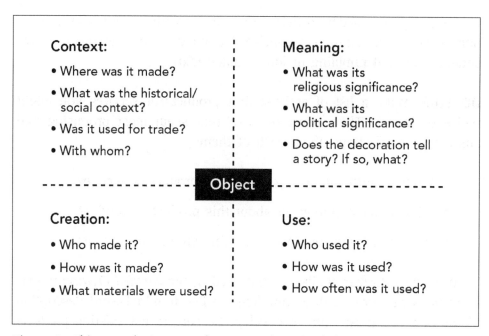

Figure 5. Object analysis example. Targeted research helps up to analyze any object or problem in greater depth. Source: Rachel Perrine and Mary Stewart.

Self-Reflection 2: Creative Challenges

Rationale: As we did with the reflection following the warm-up exercises, we must now pause to consider what we have accomplished in these challenges and where we need to go next.

DO THIS: Discuss with three to six other students the rationale for the challenges you have just completed and the order in which they occurred. Some questions to consider are listed here:

- Did you choose your product or service wisely? If so, what made it a good choice? If not, what would you do differently next time? Why?

- What did you learn in each of the challenges? Can your ideas be taken further?

- Everyone's product or service is unique, and our personal creative processes tend to vary. What was most effective, and what was missing from the strategy you used?

Making a simple rubric for each assignment can strengthen your analysis. As you did with your warm-up self-reflection in module 2, exchange your creative challenge assignments with at least two other students

and receive their work in return. Mark up your peers' work so that they can revise the entire project and ultimately submit an outstanding final result. Review their mark-ups on your work in return. Reworking our initial drafts tends to make each assignment more memorable and can strengthen our writing.

In the next section, we will experiment with six ideation strategies. To maximize our flexibility, we will use a variety of playful approaches to test drive each one. Ultimately, though, you will benefit most from these thinking strategies when you are able to apply them to your capstone assignment, starting on page 56. So, keep jotting down possible ideas for that project.

Module 4

SIX IDEATION STRATEGIES

Our first idea is rarely our best idea. It is often similar to an approach we (or someone else) used before. So, in this section we will explore a range of ideation strategies that can help you stretch your imagination and invent more solutions. The first four encourage broad idea generation; the next two help with data organization. Here's an overview:

- **Convergent thinking** is an orderly and systematic strategy that provides a step-by-step process for solving a clearly defined problem.

- **Divergent thinking** is more open ended. Typically, the problem is more loosely defined, and a wider range of solutions is possible. As a result, both the time frame and the outcomes are harder to predict. Divergent thinking is a great way to generate ideas that are revolutionary and unexpected.

- **Analogical thinking** encourages us to see similarities among different objects and events and, thus, view a problem through a new lens. An analogy can also create a bridge between what currently exists and a new approach we are considering.

- **Technological or material transfer** explores ways in which a technique, technology, or adaptation used in one context can create fresh opportunities in another.

- **Associative thinking** helps us connect related ideas. Creativity is highly dependent on seeking connections and making new combinations. Generally, the more information you have, the more connections you can make.

- **Pattern recognition** helps us avoid drowning in excessive data. A corollary to associative thinking, patterns can help us organize more complex batches of information into a useful and comprehensible form.

As we will see in the following section, many of these strategies can be combined.

STRATEGY 1: CONVERGENT THINKING

Clearly defined problems may be solved systematically.

Rationale: A systematic approach is often used when we are working in a group, our goal is clearly defined, and our time frame is limited. Team members can plan more effectively when the problem-solving process is sequential, deadlines are explicit, and everyone's efforts are focused on a single goal.

Convergent thinking provides such a systematic and sequential process. Using careful problem definition, the convergent thinker focuses on the target and then relentlessly pursues the best answer. The scientific method is a good example of convergent thinking. In its simplest form, it typically consists of six steps:

1. What do you observe?

2. What question do you have about what you observed? Is there anything unexpected or anything that challenges conventional wisdom?

3. What is a testable explanation (**hypothesis**) for your observation?

4. What do you predict will happen?

5. What actually happens?

6. What do you conclude?

For a scientist, every step in the process needs to be carefully constructed, with scrupulous attention to data collection and analysis. If the sample size in an experiment is too small or is poorly designed, the entire experiment loses credibility.

Offering clear boundaries and specific guidelines, convergent thinking helps us to achieve a clearly defined goal within a specific time frame. Here's a simple example: You want to take a week-long trip. You want to have an adventure but are low on cash. If you want to try volunteering, you might contact the Red Cross, Habitat for Humanity, or another nonprofit. If you want to get away and simply relax, a beach trip sounds great.

And then, what is your strategy? In many cases, you will need to travel somewhere. What are the options by car, train, air, or bicycle? Will this be a solo trip, or will you travel with friends? What are your lodging and meal options? What weather is predicted? Finally, if it is a group adventure, what would be an ideal outcome for each participant? An honest answer to this last question might inspire you to rethink your earlier questions.

STRATEGY 2: DIVERGENT THINKING

Exploring widely can reveal new possibilities.

Rationale: A more open-ended approach is often used when the problem is more loosely defined, and highly inventive results are required. Rather than simply focusing on a clearly defined end point, the divergent thinker explores the widest possible range of options.

Consequentially, *divergent thinking* is generally more expansive than convergent thinking and specific results are harder to predict. A single word or idea can act as the springboard into a range of possibilities. For example, in the idea map shown in figure 6, the word *passage* is the beginning point for all sorts of ideas and associations. If you need to generate even more ideas, try selecting any word from your diagram and place it at the center of a new idea map. For example, the word *flight* (in the top left corner) could generate anything from an escape from prison to the euphoria of hang gliding.

Using divergent thinking, let's try a different approach to that week-long trip. Find a friend who is driving through a town you want to visit. Pack the essentials, check your bank balance, and jump in the car. When you arrive, jump out, find a place to sleep, wander around until you find an inviting café, and, for companionship, talk with other travelers. Rather than planning extensively, just invent your trip step by step.

Ultimately, a combination of convergent and divergent thinking tends to work best. Notice how this engineering example shifts between focus and expansion:

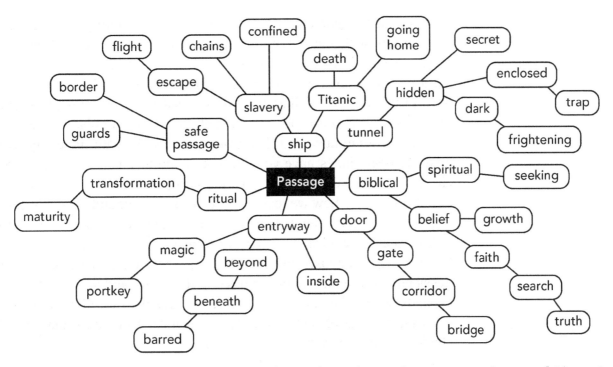

Figure 6. Divergent thinking example. A single word can be used to generate dozens of ideas. Source: Rachel Perrine and Mary Stewart.

1. Identify the problem or the need.

2. Research the requirements and determine various options and constraints.

3. Devise a large set of possible solutions.

4. Select the *best* solution on the basis of multiple considerations and constraints.

5. Test, implement, evaluate, and iterate back to repeat steps and refine definitions.

6. Report the findings and results.

When you seek greater certainty and need to weigh options logically, use convergent thinking. Use divergent thinking when you want to explore as many options as possible and are willing to overcome unexpected obstacles and pursue opportunities as they arise.

DO THIS: Working with three to six other students, select one key word from the following list:

time, light, escape, gate, power, mystery, cross, don't, barrier, survive, temper

Working alone, generate at least fifteen ideas or references. Then, share your results with the group, and working together, select at least thirty words to include in an idea map that is similar to figure 6. Next, each team member should select one word that can act as the inspiration for an artwork, a piece of literature, a proposal for a playground, a game, or a theatrical performance. Individually, work on possible solutions for around thirty minutes, and then share your results with the group. What amazing possibilities have you and your team members devised? Finally, choose an especially dramatic solution and present it to the entire class.

Note: Notice how we toggle between convergent and divergent thinking in this exercise. First, your team must *focus* on a single word from a list. Then, the idea map *expands* the possibilities in all directions. Focus is again imposed when each participant selects a single word for development into an artwork, a piece of literature, and so forth. The idea expands again when all team members engage their creativity to produce the widest range of responses. The team must focus once more on the single idea that they present to the class.

STRATEGY 3: ANALOGICAL THINKING

Connecting something that is unknown to something that is known enriches creativity.

Rationale: One of the most difficult aspects of creativity is describing your new idea to someone else. By connecting it to something familiar, you can communicate more effectively—and may see new implications for the idea yourself.

Analogical thinking encourages us to see connections between seemingly unrelated emotions, objects, or ideas. Most of us use a type of analogy called a **simile** in our everyday speech. A simile creates a connection, using the words *like* or *as*. For example, "That movie was like an avalanche of shattered glass" uses a simile to create a comparison. A **metaphor** is more explicit. It replaces one idea or object with another. Speaking metaphorically, we would say, "That movie was an avalanche of shattered glass." In the first case, we may have felt overwhelmed by the number of characters and events. In the second case, we were buried up to our waists in a complex and tragic story! The metaphor is more direct.

In either case, the qualities of the linked word become connected to the original word. This is especially helpful when our original word refers to something elusive, such as an emotion. "My child was as happy as a puppy in a park" connects a youngster to an exuberant pet. We can now envision an energetic dog galloping from place to place, greeting other dogs, catching tennis balls, and bursting with joy.

metaphor
replaces one idea or object with another.

Thus, a simile or metaphor doesn't just make the elusive emotion of happiness apparent—it makes it apparent in a particular way. When an advertisement for a new mass transit system shows a group of snails inching along, the ad conveys the tedium of a time-consuming commute. When the snails are replaced by a flight of acrobatic birds that represent the new transit system, we are more likely to remember the ad and consider taking the new train.

Here's a simple exercise using analogical thinking. Think of the smartest, kindest, meanest, or strongest characters from your favorite film or novel. Then, invent at least ten analogies that can bring these characters to life for someone else. Consider animals, objects, settings—anything that can tangibly express your perceptions. Using *The Hunger Games* as an example, we might say that Katniss Everdeen is

- as angry as a buzzing hornet's nest,

- as fierce as a wolverine,

- as unstoppable as a freight train.

And, we might say that President Snow is

- as vicious as a dagger in your guts,

- as frightened as a cornered rat,

- as dangerous as a bleeding artery.

One notable characteristic of analogical thinking is its variability. I am interested in nature, so my examples often reference animals. You may come up with completely different analogies for the same characters. Audience response is also extremely variable. A comparison that might seem witty in one context could be highly offensive in another. When in doubt, it is smart to test-drive your analogy with several friends before presenting it to an entire class.

Connections that are close enough to make sense, yet unexpected enough to create surprise, tend to be dramatic and memorable. "She has a razor wit" and "He is as quick as a cobra" both paint vivid pictures: we can visualize a razor or a snake. Specificity helps. "He is lost in the labyrinth of self-doubt" is different from "He is lost in a quagmire of self-doubt." With a labyrinth, he doesn't know which way to turn. A quagmire may be made of quicksand that is pulling him downward.

DO THIS: Find at least four ads that use analogies to increase their impact. (Sports drinks and car ads offer many examples.) Select one

to present to three to six other students and then discuss how an analogy was used to heighten the brand's message. Then, select the most memorable example from your small group and present that to the class. What makes that example memorable? Are there alternatives that could reach college students even more effectively?

Real-World Example 1: A Mini Cooper ad (figure 7) begins with a car driving around the narrow streets in an ancient Italian city. The single car soon splits apart, creating over a dozen duplicates, all zooming across cobblestone streets and through plazas. They eventually fly into the air and float over the city, finally landing on the deck of a boat just as it leaves the dock. The cars are like toys. It is hard to imagine them ever needing repair, belching fumes, or getting stuck in traffic. The ad, which is eye catching and entertaining, implies that the Mini is as agile as a toy and fun to drive.

Real-World Example 2: Several years ago, I was developing a new type of art appreciation textbook. Unlike traditional books of this kind, it provided examples of ways for students to create their own visual compositions. I described it thus:

> Metaphorically speaking, *Art: Image, Object, and Idea* is constructed from aluminum and glass rather than concrete and stone. This book will be authoritative without being authoritarian. The hands-on assignments will invite active learning and thus increase student engagement. Rather than standing on a sidewalk, watching a parade of historical masterpieces march past, students will have the opportunity to create their own means of expressing ideas visually.

Figure 7. Mini Cooper car advertisement. In this playful ad, a single car multiplies and zooms around a historic city. Source: YouTube, dzignincdotnet, https://www.youtube.com/watch?v=PUxlWrQYmj4.

STRATEGY 4: TECHNOLOGICAL OR MATERIAL TRANSFER

Shifting from one technology or material to another can spark surprising opportunities.

Rationale: Each technology or computer program has specific strengths. Adobe Photoshop is designed for photographic manipulation; Illustrator is a better choice for high-contrast graphic-design work. Likewise, each material has distinctive characteristics. A sculpture made of wood is constructed using saws, sanders, drills, glues, and screws; a sculpture made of cast bronze typically begins with a wax form that is used to make a mold into which hot metal is poured.

Technological or Material Transfer can provide us with another perspective on an idea and suggest ways to expand or modify our approach. Because technologies and materials are so distinctive, a shift in either can produce surprising results.

Real-World Examples: The mass-produced metal chair in figure 8 is lightweight, inexpensive, and easily stacked and stored. We often use chairs of this kind in group offices or community spaces. The director's chair in figure 9 is made of wood and fabric. Equally lightweight and inexpensive, it can be folded and moved from place to place as a film is shot. The expensive executive chair in figure 10 is both commanding and comfortable. The leather padding supports the user during long workdays, while the metal wheels provide mobility within an office.

Figure 8 (left). Basic metal chair. This chair is inexpensive, lightweight, and can be stacked. Source: Shutterstock. Figure 9 (center). Director's chair. Used by film directors, this wood and fabric chair can be folded and easily moved. Source: Shutterstock. Figure 10 (right). Office chair. A combination of metal, plastic, and leather creates a chair that is both comfortable and authoritative. Source: Shutterstock.

The conceptual implications of each material are equally important. We associate wood with nature, plastic with functionality, and leather with wealth and power. The Swahili chair shown in figure 11 combines traditional materials such as wood, ivory, bone, and cotton fiber with a design that is more typically European. Known as a *chair of power*, it demonstrates connections between imported and indigenous influences in Kenya during the nineteenth century.

Likewise, every information medium has its own characteristics. Consider Martin Luther King Jr.'s "I Have A Dream" speech, delivered to a crowd of over 250,000 people during the March on Washington in August 1963. It simply existed as a collection of written words until King began to improvise, repeatedly using the phrase, "I have a dream," for emphasis. He was recorded, photographed, and filmed, creating three historical records. Many murals, posters, and postage stamps have since commemorated the event (figure 12). And, if a similar speech were given today, it might be delivered via Zoom or on social media, allowing the audience to add comments right after the speech.

Figure 11. Swahili chair from Kenya. Made of wood, ivory and cotton fiber, this chair was designed to enhance the authority of the ruler. Source: Restricted gift of Marshall Field V/Art Institute of Chicago. Public domain.

Figure 12. Martin Luther King Jr. postage stamp by Keith Birdsong. One of the many visual representations of King's most famous speech, this stamp includes an image of the Washington Monument. Source: Shutterstock.

DO THIS. Using one of your previous ideas (or selecting a new object or event), list at least four ways in which your choice might be transformed or expanded through a change in material or technology. If you are exploring a change in technology, also consider ways in which multiple platforms might be linked to expand the information provided or actively involve participants.

STRATEGY 5: ASSOCIATIVE THINKING

Batching related ideas improves comprehension and invites connections.

Rationale: Innovations rarely appear out of thin air. More often, they are derived from the expansion, connection, or recombination of existing ideas. Associative thinking helps us create unexpected connections and places free-floating ideas into more comprehensible "boxes" of similar information.

Associative thinking is mainly useful in two ways. In one way, this strategy can be used to organize ideas based on a common characteristic. For example, we might list as many types of birds as possible or every conceivable food that is red in color, from raw beef to peppermint candy. In such a case, we are deliberately thinking inside the box, by limiting ourselves to types of birds or red foods. In another way, associative

thinking can help us connect ideas that previously were separate. For example, rather than seeing each chair we encounter as a completely unique object, we can notice the similarities among all functional chairs.

Especially when we are overwhelmed by excessive amounts of data, being able to place similar ideas or questions into a series of categories can help us increase focus. Figure 13 depicts a typical idea board in its initial stage. Using Post-it notes in various colors, meeting participants were encouraged to generate as many ideas as possible within twenty minutes. The initial board looks pretty confusing. The team then organized the results in useful categories, each of which addressed one aspect of the problem (figure 14). What had been chaotic then became more comprehensible and, thus, more useful. The *parking lot* category at the far right provided room for ideas that didn't fit in any predictable category. Parking lot ideas can generate new solutions to the problem at hand or may later be applied to other problems.

Real-World Example: Associative thinking has been used effectively in the development of books, radio programs, college courses, and conferences. Author Mark Kurlansky has built a career using associative thinking. *Paper: Paging through History* is his 416-page book dealing with uses and production of paper. By devoting the entire book to one subject, Kurlansky is able to focus his research and create comparisons across cultures and over time. The TED Radio Hour also

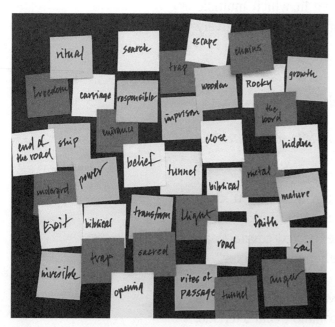

Figure 13. Initial idea board. Quantity is more important than quality at this stage. When participants use different colors, ideas that are posted can be connected back to each person. Source: Author.

Figure 14. Organized idea board. Ideas that are organized into categories are easier to assess and understand. The "parking lot" on the right side includes interesting ideas that may be too far out to be useful. Source: Author.

demonstrates the power of associative thinking. The host chooses an intriguing topic and then explores it from four to six perspectives. As with analogical thinking, the examples used must be sufficiently connected to make sense, yet broad enough to help us view the topic from multiple (and often surprising) angles. For example, an episode titled "Simple Solutions" included presentations by a designer, a chef, a sleep researcher, a public health advocate, and Amos Winter, the engineer who led the Leveraged Freedom Chair design team (see page 16).

DO THIS: Working with two or three others, select an interesting topic and then generate as many ideas and events as possible. For example, selecting the year 1968, you might list the assassinations of Martin Luther King Jr. and Robert Kennedy, the launch of the Apollo 7 and 8 space flights, riots during the Democratic National Convention—plus musical hits by the Beatles, Jimi Hendrix, Marvin Gaye, and Aretha Franklin. Intel (the leading manufacturer of computer chips) was founded that year, and McDonald's Big Mac was introduced. Alternatively, you might choose a city (such as Chicago), a song, or another subject that is loaded with ideas and implications.

Writing on Post-it notes, try as a group to generate at least forty ideas or events related to your topic. Then, try organizing them in various ways. For 1968, you might try a chronological grouping by months, or you might try using politics, music, inventions, and tragedies as your categories. Then, step back. What does this information reveal about your selected topic? Can you insert additional content into your categories to make them richer?

Note: When we have too few ideas, associative thinking can provide a mental catalyst. When we have too many ideas, it can help to create connections and add a sense of purpose to our work. Such order and purpose can help facilitate effective action.

STRATEGY 6: PATTERN RECOGNITION

Rather than seeing each event as unique, by seeking patterns we can understand connections.

Rationale: Just as a roomful of strangers can be overwhelming, so a barrage of isolated events or information can seem random and confusing. While almost any type of order provides some structure, clear patterns can help us find meaning.

Pattern recognition provides us with various means of identifying patterns. Charles Darwin's *On the Origin of Species* (figure 15) is one example. Darwin didn't just observe similarities and differences among animals on various islands in the Galapagos; he used this information to develop a new way of thinking about evolution. This drawing shows a remarkable variation in the beaks of finches on different islands. Forced to adapt to the foods available, some birds have strong, broad beaks for cracking tough seeds, while others have the narrow beaks needed for eating softer cactus seeds. When Darwin collected enough information, he was able to see a pattern that demonstrated that species evolve to meet the demands of specific environments.

Real-World Example: Historians have been enchanted by Mayan glyphs since the rediscovery of sites such as Tikal, Chichén Itzá, and Copán. Study of the few Mayan books to survive the burning of cultural artifacts in 1562 has increased in recent years. When archaeolo-

Figure 15. Finches from the Galapagos Islands observed by Darwin. Date: 1835. Birds on each of the Galapagos Islands evolved to take advantage of available foods. Source: Chronicle/Alamy stock photo.

gists realized that there is a distinctive pattern in Mayan glyphs, they concluded that the designs are not simply decorative. Instead, every component of each glyph has specific meaning (figure 16). When combined, they identify specific historical figures and dramatic events. This realization opened the door to much greater understanding of an ancient culture.

DO THIS: For seven days in a row, spend at least ten minutes walking a familiar route. Rather than thinking about the demands on your time

Figure 16. Line drawings of Mayan glyphs. These glyphs combine multiple shapes to communicate specific ideas. Source: Washington, DC, Smithsonian Institution, 1914. Public domain.

or the friends you want to contact, fully focus on one aspect of your walk, such as the signs in shop windows, the occurrence of the color red, every type of seat (from benches on the sidewalk and blankets on the grass to seats on bicycles). You might even focus on sounds or smells. At the end of your daily "attention walk," sit down and write up your results. Then, at the end of the week, review your notes. What do these patterns reveal about your surroundings? To take this exercise further, next select a dramatically different route (such as a walk in the woods or through a very different neighborhood) and repeat the exercise. How are the two experiences similar? How are they different?

Note: The implications of pattern recognition are vast. Pattern recognition is a crucial aspect of business, economics, medicine, music, and all of the sciences. Events that are meaningless in isolation can become transformational when a pattern emerges.

Module 5

THREE SELECTION STRATEGIES

Determining which ideas are worth developing can make the difference between success and failure. We can't pursue fifty alternatives at once, and pursuing the least promising idea—while overlooking the most promising—is a costly mistake. So, we will conclude this section with three selection strategies:

- *Expanding the bandwidth* helps us identify the components of a problem and then push beyond predictable (and boring!) solutions. This approach provides us with multiple opportunities for selection within a single problem.

- *Connecting critical and creative thinking* applies to each of the preceding strategies. To proceed effectively, we must discern which option is the most promising. That option can then be developed into a great solution.

- *The parts and the puzzle* is a strategy that introduces **systems thinking**—an approach that challenges us to scrutinize interconnections among the parts in a problem and thus reach a more informed and effective solution.

systems thinking
an approach that challenges us to scrutinize interconnections among the parts in a problem and thus reach a more informed and effective solution.

STRATEGY 1: EXPANDING THE BANDWIDTH

How Can an Image, Object, or Idea Be Radically Transformed Yet Retain Its Essence? Will Such a Transformation Result in an Improved Problem Solution?

Rationale: We are often told to think outside the box. While this metaphor can be overused, it actually makes a meaningful point. If the box

only contains a narrow and predictable collection of solutions, then we need to break out, so we can imagine and propose more inventive solutions. And yet, let's remember the work we put into problem definition in challenge 3. If the problem definition creates a mental box, shouldn't it be respected? Will thinking outside the box lead us to solutions that don't address the problem we are actually trying to solve? Somehow, we need both appropriate structure and imaginative freedom.

Expanding the bandwidth can help us retain sufficient structure while at the same time encouraging us to pursue unexpected possibilities. Using this strategy, we can break a problem into a series of components and then push each component to the extremes. We can later weigh the results and decide which may spark an out-of-the-box breakthrough.

How does this work? Figure 17 is a diagram of a simple slider box. Commonly used to speed up or slow down musical tempo, control volume, adjust the mix from treble to bass, and so forth, a slider box gives us an easy way to experiment with various aspects of sound. Rather than operating in the predictable midrange, what happens when we crank the volume up to a wail or down to a whisper? How quickly or slowly might a musical passage be played?

Let's consider the architectural implications of expanding the bandwidth. How airy or enclosed can we make the building? How horizontal or vertical should it be? How varied or consistent should we make its surface? Should its circulatory system be concealed inside, or can it be placed on the outside, as a colorful accent? This is exactly the approach architects Renzo Piano and Richard Rogers used for the Centre Pompidou in Paris (figure 18), one the of most distinctive art museums in the world.

Figure 17. Basic musical sliders. In each category, the amount increases when the slider is moved upward. Source: Rachel Perrine.

Figure 18. Renzo Piano and Richard Rogers, Pompidou Center, Paris, France, 1976. By placing colorful ventilation systems on the outside of the museum, the architects increased the interior space and created a cultural icon. Source: Shutterstock.

DO THIS: If you are adept at digital imaging, create a series of portraits including two source images and a word or phrase. As shown in this example (figure 19), I began with a fairly neutral source image of a friend in a city park. The first three variations are quite similar

Figure 19. Basic selfie variations, 2020. The initial shot is fairly emotionally neutral. Addition of text and a different background change the meaning. Source: Photo by Rachel Perrine, variations by author.

in text, concept, and layout. The fourth (figure 20) expands the bandwidth more dramatically. The screaming monkey becomes an avatar for the calm woman, suggesting that she has hidden feelings. And, by multiplying the monkey image or trying other animals, I could take this much further. A brooding owl could suggest sorrow, while a flight of geese could suggest freedom. We rarely break free before we complete at least five variations, so it is helpful to crank out designs fairly quickly rather than try to polish our initial attempts.

The point of this exercise is to practice pushing beyond the obvious or conventional solution. If you are an event planner, break down one of your past events into three or four components (such as location, time of day, duration, and activities), and consider how you might have done it differently. If you are a carpenter, consider how a wall of shelves might be re-envisioned. If you are a teacher, identify at least three components of an assignment (such as duration, forms of instruction used, and types of student engagement), and consider alternatives.

Note: This exercise can be useful even when we don't implement any of the extreme solutions. It helps us to better understand the components of a problem and thus to think outside the box while retaining focus on problem essentials.

Real-World Example: Architect Frank Lloyd Wright's Fallingwater (figure 21) is one of many architectural examples of expanding the bandwidth. Rather than placing the house near the bottom of the waterfall (as the client expected), Wright considered a wider range of possibilities and then placed the house right *over* the waterfall. As a result, residents continually hear the moving water and are more strongly connected to the river.

Figure 20. Expanded selfie variation, 2020. This is a more inventive solution. Both the woman and the chimp are now so upset that they are dissolving in rage. Source: Photo by Rachel Perrine, variation by author.

Figure 21. Frank Lloyd Wright. Falling Water, 1935. Rather than placing the house near the bottom of the waterfall, Wright placed the house over the waterfall. Source: Library of Congress, Prints and Photographs Division. Public domain.

STRATEGY 2: CONNECTING CRITICAL AND CREATIVE THINKING

Inspired by text developed by Dr. T. Lynn Hogan, Assistant Provost, Florida State University.

Rationale: As we found through the warm-up exercises and creative challenges, critical thinking is an essential aspect of creative thinking. Brainstorming helps us produce lots of ideas but is meaningless if we are unable to select and develop the best one. In preparation for the capstone assignment, we will explore critical thinking more deeply in this final section on thinking strategies.

A detailed seven-step critical thinking process is listed below. When the problem is complex or its definition is elusive, all or part of this sequence may need to be repeated.

1. *Listen and observe.* Active listening involves concentrating on what is heard and what it could possibly mean. Active observation requires us to take in all information before reaching a conclusion. Like a skillful detective, without making judgements, we might first note a patch of dead

grass on a pristine lawn. What caused it? To reach effective conclusions, we must understand the puzzle being presented and *then* explore its meaning.

2. *Ask appropriate questions.* Appropriate questions clarify the problem at hand and illuminate its implications. To reach a good solution, we may need to ask very practical questions, such as:

 • Where will the final result be presented?

 • How will the information reach its intended audience?

 • How can the inventor get feedback from the users?

 • What aspects of the problem must be solved collaboratively? What can be done solo?

When we are working collaboratively, it is important for everyone to form and ask questions. When one person dominates the conversation, others tend to shut down. How we pose a question is also important. "How can we build a shelter?" is a much broader assignment than "How can we build a house?" A shelter could even include developing psychological resilience, while a house tends to suggest a fairly narrow range of physical structures.

It is also helpful to identify solutions that must be excluded from the range of possibilities. For example, no matter how brilliant it may be, a paper that is written in German is unlikely to be accepted in a Spanish language course.

hypothesis
a proposition put forth as a possible solution.

3. *Develop an initial hypothesis.* Through the process of observing and questioning, we can develop a preliminary **hypothesis**, which is a proposition put forth as a possible solution.

4. *Gather relevant information.* In its broadest form, critical thinking generally uses three types of research to further expand our understanding; they include

 • observational research, focusing on physical evidence or specific behaviors;

 • periodical research, requiring a review of what has been written or designed by others; and

 • ethnographic research, focusing on larger cultural issues that give meaning to behaviors and artifacts.

5. *Sort information and prioritize possible solutions.* Listening, observing, and questioning can create a lot of data. It is helpful to step back, organize the data, review the initial problem, and prioritize our possible solutions. Creating a rubric can help us weigh the strengths and weaknesses of each alternative on the basis of specific criteria.

6. *Test possible solutions.* For artists and designers, thumbnail sketches (such as figure 22), small-scale three-dimensional prototypes, and digital variations are all excellent ways to test solutions. Fiction writers produce many drafts, sometimes highlighting the actions of one character, sometimes highlighting the actions of another. And the testing process in science or engineering tends to be especially rigorous.

Figure 22. Thumbnail Sketches, 2020. Each quick drawing gives just enough information to express an idea. Source: Author.

7. *Evaluate results based on deeper understanding of the initial question.* Our understanding of the initial question constantly evolves as we seek a solution. Thus, our evaluation of results at this stage should go well beyond our initial bare-bones understanding.

STRATEGY 3: THE PARTS AND THE PUZZLE

The more fully we understand a problem, the more effectively we can make decisions.

Rationale: Almost any decision can be improved when we more fully understand the context and the potential consequences of our actions. Rather than simply focusing on the separate *parts*, to gain greater understanding we must look at the *puzzle* as a whole.

As mentioned earlier, this approach is typically called systems thinking. As with design thinking, entire courses are devoted to this topic, especially in colleges of business. Because this is an introductory text, our discussion will be more concise and will include examples of systems thinking in several fields. This section will conclude with an exercise in identifying systems—which may spark significant new insights, or simply provide a broader understanding of ideation and implementation.

Background: Perhaps the most basic example of shifting between the parts and the whole is a jigsaw puzzle. It is nearly impossible to complete a puzzle without referencing the picture on the box; without that, the hundreds of shaped pieces become meaningless (figure 23). With a picture (figure 24), we can begin grouping sections by color, create an outer edge, and then gradually fit the pieces together. The puzzle makes more and more sense as each fragment snaps into place.

If only creative problems were as straightforward! Rather than happily creating an image of a cat dreaming of a magic carpet ride, we may be ordering supplies from multiple sources, working with various production teams, selling to individuals and corporations, meeting safety standards, revamping our employees' health care, and much more.

Figure 23. Random puzzle pieces. Random Puzzle Pieces. When we open the box, we are confronted with a problem to solve. Source: Author.

Figure 24. Space cat jigsaw puzzle. Any puzzle makes more and more sense as pieces fall into place. Source: Mark McEvers and Author.

Regardless of the complexity, all systems are typically comprised of elements (that is, the puzzle pieces), interconnections (how they are put together), and the ways in which they fulfill their function or purpose (in this case, the picture they create). Let's analyze this further:

- *Interconnectedness* is at the heart of systems thinking. Instead of focusing on each part in isolation, the systems thinker seeks to identify and understand the ways in which parts relate to each other. As in a natural ecosystem, everything is reliant on everything else. Failure to understand such interconnectedness has led to a sorry history of short-sighted environmental choices, such as excessive fire suppression (resulting in fewer but more damaging fires) and the eradication of predators (resulting in an overpopulation of deer).

- *Synthesis* occurs when we combine two or more things to create something new. *Analysis* involves breaking things apart to examine components individually. Although both are important, the systems thinker focuses on synthesis as a way to understand and then maximize the power of connections. Just as hydrogen and oxygen create the unique power of water when combined as H_2O, so synthesis can transform a business or organization.

- *Emergence* refers to the way in which larger things arise out of smaller things or events. For example, during an epidemic, one carrier of a disease may only infect three other people. However, if each of those people then infects three more, and each of those people infects three more, the world will be well on its way to another pandemic.

- *Cause and effect* occurs when everything is interconnected; a change in one part of a system tends to cause a change in every other part. For example, even a minor leg injury and subsequent months of limping can throw off one's overall balance or even cause back problems. Or consider this example: after extensive research, a team of engineers has concluded that substandard rivets (the pins that connect steel plates together) may have played a significant role in the sinking of the *Titanic* when it struck the iceberg!

Systems thinking is particularly well suited to situations that change quickly. Many sports provide examples of such dynamic systems. The 1980 "Miracle on Ice" United States Olympic hockey victory is an espe-

cially dramatic case. On paper, the American team (composed of college students with an average age of twenty-two) didn't have a chance against the formidable and experienced Soviet team, which had won each of its Olympic games since1968, plus many other championships.

However, coach Herb Brooks identified and used multiple systems to give his team an edge. Known as a tough disciplinarian, he required each potential team member to take a psychological test that would assess his strengths, weaknesses, and emotional resilience. He selected players based on their potential emotional as well as athletic contributions to the team and thus didn't simply recruit brilliant individual players. Furthermore, Brooks taught a fluid, highly mobile style of play that actively encouraged subgroups of players to seek and exploit opportunities. The United States' players couldn't possibly beat stronger and more experienced players when matched up one-on-one, but they could (and did) succeed by identifying and exploiting the interconnected relationships inherent in each game they played (figure 25).

Here are some other examples of systems thinking:

- A garden comprised of plants bought on a whim may be glorious, but a farm is a system. To be successful, the farmer must prepare the soil, select and grow the right crops, sell them at a profit, and keep good financial records.

Figure 25. Team captain Mike Eruzione holds the Olympic torch shortly before he and the rest of the 1980 gold medal hockey team lit the flame for the Salt Lake City Olympics in 2002. Source: Reuters/Sue Ogrocki KM/HB.

- If a stock increases in value, buying it on a hunch may be good entertainment, but a financial portfolio is a system. Skilled financial advisors balance various market sectors rather than just buying stocks in one sector (such as banking or transportation). They balance higher and lower risk investments, consider the tax implications of each sale, and make long-term plans.

- An invention may be brilliant, but without financing, the right manufacturer, and effective marketing, the innovation will have limited impact. All of the parts must fit together.

- Your skeleton is a system; a random pile of rocks at a construction site is not.

Systems mapping is an effective way to visualize the many interconnections within a system. Such maps often begin as a loose bubble diagram (figure 26) and then become more refined as an organization seeks to identify opportunities to exploit and problems to be solved.

A team of collaborators completed figure 27 as part of a systems thinking intensive. The three black circles identify major components of the problem of workplace readiness for college students. The team wanted graduates to be prepared and satisfied, sought university effectiveness in

Figure 26. Bubble diagram. Like a thumbnail sketch, a rough bubble diagram can be used to lay out basic ideas quickly. Source: Jake Arsenault.

achieving this goal, and highlighted the importance of employer satisfaction. The smaller "moons" floating around these "planets" identify the many factors or decisions that could contribute to or detract from realizing these goals. Color coding (such as the use of yellow for areas that are changing rapidly), along with the use of plus and minus signs, helps the team identify possibilities, impacts, and obstacles. Like a water bed, when the weight shifts at one end of the system (a large dog suddenly jumps onto the bed), the impact is felt throughout the system (a dozing cat tumbles off the other end!).

As noted at the beginning of this discussion, entire courses are devoted to systems thinking and the extensive systems mapping it requires. If you are interested, consider taking a free online Acumen course (https://acumen.org/) or an entire college course in systems thinking.

DO THIS: For now, simply identify and describe at least three types of systems to four to six class members. Keep the three essentials in mind.

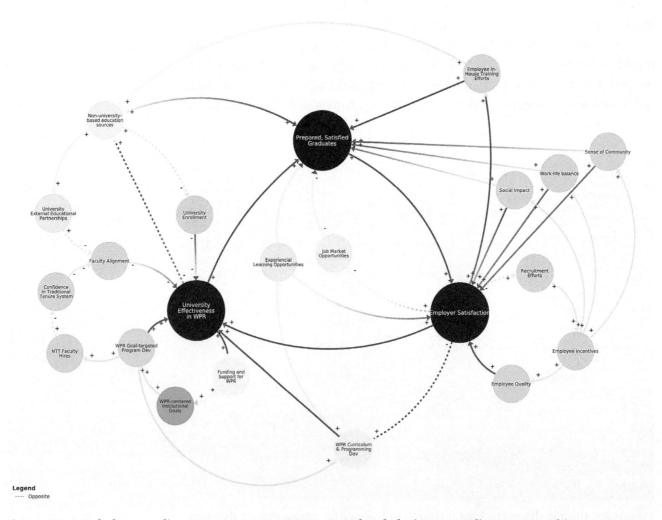

Figure 27. Workplace readiness system map, 2019. Completed during an online course, this system map shows interrelationships among multiple parts in a problem. Source: Ken Baldauf and collaborators.

A **system** is a group of interconnected elements that work together to achieve a common purpose. Please note that complex structures often combine multiple subsystems. For example, a curriculum (such as a college major) is a system comprised of multiple courses (which are also systems) that present a variety of assignments (which may also be systems)!

Self-Reflection 3: Idea Generation and Selection Strategies

Rationale: We all solve problems using a mix of prior knowledge and new information. By recognizing our existing strengths and identifying the additional skills we need, we can actively develop new capabilities, strengthen self-awareness, and become more independent.

DO THIS: For the first two self-reflections, we used a group work strategy. This time, develop your own process for reviewing your work, using the idea generation and selection processes presented in modules 4 and 5. What skills have you gained? What exercises might you revise and improve? How can this information be applied to your other coursework? As before, take time to develop a rubric if that will help your analysis.

Module 6

DEVELOPING A CAPSTONE PROJECT

A Capstone should be demanding, yet must be achievable. If your class is only ten weeks long, it may need to occur in a later course. You are still exploring and inventing, so don't expect to have all of the answers right away. Just create the best overview you can, and then revise it as you gain understanding and refine your strategy. Review the four sample proposals on pages 57 to 68 to get a better sense of the range of possibilities.

WRITING A PROPOSAL

What Problem Do You Want to Solve? Why?

Rationale: Creative thinking requires an increasing level of independence and self-confidence. It cannot flourish when we simply follow rules set by others. The following capstone project gives you an opportunity to dig into a project you care about deeply.

DO THIS: Based on the following format, write up your project plan. Depending on your discipline, you may need to add or subtract several questions to make the proposal more useful.

CAPSTONE PROJECT PLAN FORMAT

Title: Give your project a descriptive and memorable title. You want it to stand out—and the title itself can help to distill your intentions. Be as specific as you reasonably can. "I plan to complete six 18″ × 24″ drawings, showing pivotal moments from *The Hunger Games*," immediately gives the reader a clear sense of your intentions.

Investigator(s): Who will complete the work?

Problem Description: What do you plan to do?

Significance: Why is it important?

Audience or Users: Who will gain from the result?

Existing Solutions to Similar Problems: Try to identify and describe at least three. What are their strengths and weaknesses?

Potential Supporters: As a student, you are surrounded by helpful people, including your instructors, other students, advisors, and possibly a college leadership center or technical assistants in a lab. How might any (or all) of these folks contribute to your project?

Targeted Research Questions: Refer back to challenge 4. What were the most important questions you answered in that assignment? What are the most important questions to answer as you start this assignment? To help with your targeted research, consider developing (and eventually answering) a series of questions that are similar to those in figure 5.

Targeted Research Resources: What books, videos, workshops, websites, or other resources can help you solve your problem?

Ideation and Selection Strategies to Use: Review modules 4 and 5. What strategies could be most helpful?

Potential Obstacles: What obstructions could slow your progress?

Criteria for Success: In your mind, what would constitute success? Using a rubric (as in warm-up exercise 3) can help you develop clear criteria.

Projected Timetable: What parts of the project need to be completed each week? A projected timetable helps break a complex problem into a series of manageable steps. Revisions are likely as the project unfolds—but in the absence of a timetable, it is very easy to procrastinate or get derailed. After you have completed a well-developed draft, share it with at least three other class members. Get their advice, and offer advice on their proposals. Then, submit it to your teacher or advisor for approval.

FOUR PROPOSAL EXAMPLES

Our first example was inspired by an anonymous student project from a Central Oregon Community College writing class, dated 1999. For our purposes, I have completely rewritten the proposal so that it is much shorter and better matched to the format we are using in this book.

HISTORY

Japanese American Internment during World War II: A Cautionary Tale
John Doe, Investigator

DESCRIPTION

This project will focus on Japanese American internment in concentration camps during World War II. Even though the internment reveals a lot about American attitudes toward race and politics, this subject is rarely discussed in our schools today. I plan to learn as much as possible and then want to share my knowledge widely using an online platform, such as YouTube.

RATIONALE

Immigration is a controversial subject today, and the housing of asylum seekers in camps is problematic on many levels. Are the perceived threats posed by immigrants justified? What happens socially when a selected group of people is detained? How can a nation best control immigration? As a history student, I am in a better position to study the past than to comment on the present. However, knowledge of the past may help us better deal with the present.

AUDIENCE

The initial audience for my research is my college classmates. I will give a ten- to fifteen-minute presentation in class and make improvements based on the feedback I receive. I then plan to post a revised presentation online.

LEADING RESEARCH QUESTIONS

- What was the American government's rationale for creating the internment camps?

- What problems did the interment solve, and what problems did it create?

- How did unaffected American citizens respond to this decision at the time?

- What was the impact on the Japanese Americans who were placed in the camps?

- From a historical perspective, were the camps justified?

- What can we learn from this historic episode?

PROJECTED SOURCES

I expect to use a combination of books, audio files, and online resources. Biographies from internees may be especially valuable. My projected research topics are listed here:

- Attack on Pearl Harbor

- Japanese-American internment during WW II

- World War II 1939–1945

- United States concentration camps

PROJECTED RESULTS

I plan to complete a fifteen- to twenty-page research paper using the *Chicago Manual of Style*'s documentation style for the humanities. I will then create and deliver a PowerPoint presentation that builds on the paper and includes as many visuals as possible, including video clips.

CREATIVE THINKING STRATEGIES

I expect to use associative thinking to help me organize information and pattern recognition to help me analyze what occurred and why.

PROJECTED TIME MANAGEMENT

- Weeks 1 and 2: Complete broad online research and read at least two books on this topic. Review at least four general-audience articles from the period, using *Life*, *Look*, and *Time* magazines.

- Week 3: Read more deeply into the politics of the period, including editorials published by leading newspapers and political commentators. Radio was a major means of communication during this period, so reading (or hearing) presentations by political leaders and commentators will help me understand more about the emotional and political currents surrounding the internments.

- Week 4: Develop an outline and get it approved. Begin work on my rough draft.

- Week 5: Complete the rough draft and get it approved. Begin work on final paper.

- Week 6: Complete and submit the paper. Begin work on the PowerPoint.

- Week 7: Complete and deliver PowerPoint presentation. Write a self-reflection on the project.

Our second example is inspired by an actual project completed by illustrator Jason Chin when he was a student in my basic design class at Syracuse University in 2000. His project, titled *The Mythological Alphabet*, became a springboard for his highly successful career as a children's book illustrator. For this example, I've developed a proposal for an innovation alphabet blog.

ENGINEERING
The Innovation Alphabet

INVESTIGATORS

Janika Doe, Elan Gonzales, Marco Hart, Lars Horita, Adriann Overmann

DESCRIPTION

Using the letters of the alphabet as a basic structure, we will design and launch a blog devoted to innovation. The projected work period on this blog is six weeks, with each team member responsible for one post per week once the blog is set up and tested.

RATIONALE

Through this project, we can

- share the innovation strategies and inspiring biographies we are learning about in our courses;

- practice collaboration in the ways we divide the work and stay on task;

- build a sense of community with other students, at both our campus and across the globe; and

- playfully demonstrate our inventiveness to potential mentors from any discipline.

AUDIENCE

Students, faculty, and potential mentors, both on campus and off.

STRATEGY

Each post will be inspired by a letter from the alphabet. Each team member will complete five posts, resulting in twenty-five total. The twen-

ty-sixth post will be completed together or by the team member who has time at that point. To make sure that we are able to sustain the weekly posts once the blog is launched, we plan to complete at least ten posts in advance (see timetable). Beyond that, we plan to meet once a week to review our progress and reply to responses.

CREATIVE THINKING STRATEGIES

We plan to start with divergent thinking, which should help us expand our ideas and build a shared understanding of possibilities. Associative thinking can then help us organize our thoughts and select the best option for each letter of the alphabet.

TIMETABLE

Week 1: Develop ideas for various letters of the alphabet and divide the work. Determine the best blog format, set up the blog, and test it.

Weeks 2 and 3: Complete the first ten posts and then launch the blog.

Weeks 4, 5, 6: Complete the remaining fifteen posts and respond to readers.

Week 7: Review the entire project and write up final self-reflections.

EXISTING SOLUTIONS TO SIMILAR PROBLEMS

We all loved alphabet books when we were children. They seemed to provide just the right balance of structure and surprise. We were delighted when the author dealt with each letter in an inventive way. As adults, we seek greater complexity. The dark humor in Edward Gorey's *The Gashlycrumb Tinies, or, After the Outing* ("A is for Amy who fell down the stairs; B is for Basil assaulted by bears . . .")[3] is refreshingly unexpected. Harryette Mullen's fifth poetry collection, *Sleeping with the Dictionary,* is inspiring. Existing alphabet books and blogs tend to be aimed at preschoolers. Our blog will be aimed at aspiring entrepreneurs and thus needs to have more weight.

RESEARCH QUESTIONS

How broadly can we define *alphabet*? Could we reference languages other than English? What stories do we want to tell? Should we focus on inventions, inventors, organizations—or can all three provide ideas for posts? What is the best balance between consistency and inventiveness?

POTENTIAL OBSTACLES

How can we sustain momentum through the entire project? What happens if someone becomes ill or is overloaded with other coursework?

FORMAT

Each post should be 250–700 words in length and include at least one image.

CRITERIA FOR EXCELLENCE

Ideally, each post will be informative, accurate, and engaging. The entire project should include examples of innovation in multiple fields by a diverse range of innovators.

ART

Our third example is a project that an art major might pursue. It is too big to be fully completed in the time frame available, but this student wisely plans to develop it further within her art degree coursework.

The Vietnam War: Four Perspectives
Investigator: Jane Doe

DESCRIPTION

I plan to create at least four large drawings dealing with the perspectives of four relatives who were involved in the Vietnam War or in the protests that occurred during that time. At age twenty, my father was drafted. He served until he was wounded and discharged two years later. His sister (my aunt) was active in the antiwar movement from 1970 to 1972. My grandfather, who had served in the Army during the Korean conflict, was a strong supporter of the government and appalled by the antiwar protests. Finally, my mother tried to be a family peacemaker while raising a growing family.

RATIONALE

My knowledge of this period, as well as my understanding of the motivations and feelings of my relatives, is fragmentary. I've always wanted to know more, and this project gives me a chance to interview each character in this family drama. I've just finished watching Ken Burns and Lynn Novick's series *The Vietnam War*, and I am developing an extensive reading list, including books and periodicals.

AUDIENCE

This project is really aimed at others like me who struggle to understand complex family histories and underlying conflicts. Whether the conflict is

driven by the Vietnam War or by more recent political or social movements, everyone has a distinctive perspective. What is their point of view, and how did it develop?

CREATIVE THINKING STRATEGIES

This project will require extensive research and conversations with relatives. I think that expanding the bandwidth combined with iteration will serve the project best. I plan to complete one or more drawings for each of my four characters, each measuring 18″ × 24″ or larger.

BACKGROUND RESEARCH

My research will include interviews, readings, videos, and films. A preliminary list of books follows: *A Rumor of War*, *by* Philip Caputo; *Dispatches*, by Michael Herr; *Bloods: Black Veterans of the Vietnam War: An Oral History*, by Wallace Terry; and, especially, *Father, Soldier, Son: Memoir of a Platoon Leader in Vietnam*, by Nathaniel Tripp. My list of films and videos includes the Burns and Novick series plus at least five from the *Military Times'* list of best Vietnam War films, such as *We Were Soldiers* (2002), *Born on the Fourth of July* (1989), *Full Metal Jacket* (1987), *Platoon* (1986), and *The Deer Hunter* (1978). Leading periodicals of the day include *Time*, *Look*, and *Life*. I also plan to visit the Vietnam Veterans Memorial in Washington, DC when I visit my family in Maryland during Thanksgiving.

PLAN OF ACTION

I've already gotten preliminary approval for this project and begun my research. My overall work period will be almost two months. The first month will be devoted to visual as well as historical research. Should each drawing be the same size? Should archival photographs be included? What techniques are most appropriate? This will be a time-consuming project, so I plan to rely heavily on my existing skills rather than attempt to learn a new art technique.

POTENTIAL OBSTACLES

I'm confident that my relatives will tell their stories gladly and that I will have more than enough research material. My biggest concern is that I think the scale of the project is better suited to a three-semester thesis exhibition than a two-month capstone. So, distillation will be essential. I plan to build on it further for my senior thesis.

CRITERIA FOR EXCELLENCE

Learning as much as I can about my relatives' perspectives and the overall historical context of the period is the first step; turning my understanding into drawings is the next. The artwork needs to be both insightful and dramatic, without becoming melodramatic. And the drawings need to be meaningful to a wide audience, not just my immediate family.

COMPUTER SCIENCE

Our final example proposes a computer-science project actually implemented in the spring of 2020 in response to the COVID-19 pandemic. Because of its urgency and the range of skills required, this project was completed by two teams. The programming team included Orlando Kenny, Steven Huang, Alex Jeannite, and Nathaniel Leonard, and the content team included Jordan Wiener, Mary Rufo, Gena Ferguson, RoseEllen Hoke, Nicole Ferrara, and Estefania Touza Maya. The overall project and the programming team was led by Orlando Kenny while the content team was led by Jordan Wiener.

Getting the Word Out: Building the COVID-19 Information Hub

DESCRIPTION

We propose to develop and implement COVID-Central, a website designed to provide users with reliable information, resources, and statistics regarding the outbreak of the COVID-19 virus.

RATIONALE

Information overload has long been a problem for internet users and has become even more acute with the spread of COVID-19. Timely and accurate information can literally save lives, yet it seems to be scattered across multiple websites, many of which are hard to navigate. Furthermore, none of the existing websites seems to honestly address the emotions we experience during such a dramatic event.

AUDIENCE

As college students ourselves, we feel most knowledgeable about the student audience. We want to create a site that provides essential information regarding COVID-19 quickly and accurately and then encourages users to filter through multiple resources and news articles to address an emotion. For example, if I were feeling anxious, I would click the anxious flair on the resources page. "Pick me up" articles and resources would then populate the page.

CREATIVE THINKING STRATEGIES

We expect to toggle between convergent and divergent thinking throughout.

BACKGROUND RESEARCH

This site must provide accurate information in a succinct and visually attractive way. Our research needs to provide answers to the following questions:

- What are the best sources for the latest news and statistics?

- What are the most insightful sources for broader commentary on the virus and its implications?

- What qualities distinguish well-designed websites from those that are poorly designed?

- Technically, how can the site be programmed to work well on multiple devices and multiple platforms?

- Visually, how can the site be both professional and inviting?

Our research sources will include https://www.covidtracking.com (which focuses on the United States), https://www.covid19api.com (which provides country-by-country statistics), and News API (a news feed that returns one hundred articles that mention *coronavirus* at any one time). These application programming interfaces (APIs) are all free to use due to the open-source nature of the computer-science world.

PLAN OF ACTION

To complete the work as quickly as possible, we plan to use two teams. Our content team will focus on identifying the most helpful resources and then work on designing an attractive site that is easy to navigate. The programming team will focus on implementing the design. As soon as we know enough to develop an overall framework, the programming team will begin to work on implementation, knowing that more content will be added as additional resources are found.

COLLABORATION TIMETABLE

We see this project as fulfilling an urgent need and want to get it up and running in five weeks, if possible. As students, we will be completing assignments for our classes during this same time, so balance and efficiency will be necessary. Our projected targets follow:

- Week 1: Define our mission, identify potential site features, find reliable sources, and determine user flow.

- Week 2: Sketch up what the site will look like, establish workflow, and consider ways to incorporate third-party APIs.

- Week 3: Create pages that use the simplest third-party APIs and devise a method for the research team to easily upload new articles and resources. While resources are being uploaded, the programming team can begin implementing other pages.

- Week 4: Complete remaining unfinished tasks on all pages and ensure functionality on mobile devices.

- Week 5: Debug the site and make modifications as necessary so that the site is entirely accessible from desktops. Then, meet with marketing-focused members of the research team to develop a small campaign and begin to promote the site.

Table 5. COVID-Central work chart. By identifying and clearly assigning tasks to be done, a collaborative team can work efficiently and avoid conflict

	Urgency (3 = highest)			
Issue	1	2	3	How and who to solve the problem
Breadth of content		X		Orlando and Jordan will figure out the best way to implement a card-stack format
Accuracy of content			X	Jordan will vet our sources and select the most reliable
Emotional impact of articles		X		Jordan, Mary, Nikki, Estefania, Gena, and RoseEllen will upload fifty articles with emotional content to our spreadsheet
Timeliness of statistics			X	Orlando will vet the APIs, testing how reliable they are, and how often they are updated
Ease of site navigation			X	Steven will implement a universal navigation bar
Accessibility to audience			X	Orlando, Steven, Nate, and Alex will collaborate to develop the desktop version of the site while making the least changes possible to the mobile version

URGENCY AND EXCELLENCE

As we work through this project, we will assess results at least weekly, in accordance with the rubric in table 5. We need to create the best possible result in a short amount of time. With ten team members, we need to clearly identify problems and assign solutions.

MAINTAINING THE SITE

We expect COVID-Central to remain up and running for at least one year. Because information on the site changes frequently, COVID-Central must be easy both to modify and maintain. Ideally, we will never have to change the code to upload new articles or resources. Further optimization or updates are the only maintenance issues we anticipate.

COMMENTARY

This project was completed in spring 2020. Everyone met to discuss the results and Orlando Kenny wrote the following commentary on this collaborative project:

> *COVID-Central* taught all of us to work closely between disciplines. Too often in computer science, we do not adequately consult with the experts working in the field that our site is designed to publicize. As a result, precious time is spent trying to understand the basic information rather than solve the problem.
>
> We decided that we would be most productive by splitting into two teams depending on our expertise. To keep everyone informed, we had a production version of the site ready to share at any point and just appended changes with every update. This gave us confidence that the site could be rolled out instantaneously upon completion.
>
> We were able to work efficiently by holding weekly meetings that established deadlines and allowed each team to focus on its own tasks, which allowed us to work in parallel and cross paths when needed. As a result, our individual expertise effectively advanced our collaborative project. Our ten-person work group represented multiple disciplines and thus provided the diverse viewpoints we found necessary for a general audience site of this kind.
>
> We found it very important to establish clear deadlines and trust each team member. Everyone knew what needed to

be done and when, resulting in a sense of accountability. Ultimately, the web application (figure 28) was released within five weeks of its start date and can be visited at https://www. covid19-central.com.

As these four examples demonstrate, even though capstone proposals vary based on the demands of each of our disciplines, the basic pattern remains the same. A clear description, convincing rationale, targeted research, effective action plan, and projected results are provided in every case. The ten-person COVID-19 website team especially benefited from their shared understanding of project goals and strong sense of individual responsibility. Without both, the large team could have easily fractured if members pursued individual initiatives without understanding the project overall.

Figure 28. Covid Central Website Design, 2020. The final website was informative and easy to navigate. Source: Orlando Kenny and collaborators.

ITERATION AND REITERATION

How Can an Initial Idea Evolve into a Successful Solution?

Rationale: Most innovative ideas begin tentatively. A lot of trial and error follows, leading to improvements over time. As we noted on page 7, iteration is the specific term for this evolutionary process. Through iteration, we generate a sequence of solutions. If we are able to identify clearly the strengths and weaknesses in each version and make continual improvements, our final result can evolve from a rough idea into an effective innovation.

DO THIS: At the end of each week of work on your capstone project, stop to assess your progress. What did and did not work? What adjustments in process or product are needed? As with our earlier work, sharing your results with several others in the class can expand your vision and reveal further options. We are often too quick to dismiss our potentially rich ideas and too slow to discard our weak ones!

Real World Example: The development of the airplane is a great example of iterative thinking.

In his own time (born 1452, died 1519), Leonardo da Vinci was more renowned for his engineering skills than for his paintings. Seeking a way to improve military reconnaissance, da Vinci began working on a flying machine that would provide a bird's eye view of a battlefield. (figure 29).

He sketched thousands of designs, showing the pilot lying down, standing vertically, using his arms or legs to power the contraption.[4] Use of machinery in Leonardo's pre-industrial age was minimal, and the limits of human strength made it impossible to fly his machines. As a result, they are fascinating thought experiments, not usable devices.

However, flight is a pervasive human dream, and the website of the Wright Brothers Aeroplane Company details dozens of flying machines envisioned and invented from 1799 right up to the 1903 flight at Kitty Hawk, North Carolina.[5] Much more methodical than their competitors, the Wright brothers consistently tested their ideas in small scale before building an actual plane. To determine the best wing shape and propeller configuration, they even invented and built one of the first wind tunnels. As they tried various designs, Orville and Wilbur took notes and careful measurements so that they could really understand what worked and why.

Figure 29. Leonardo da Vinci, Codex Atlanticus. Design for a flying machine, 1478–1519 Milan, Pinacoteca Ambrosiana. Source: Painting/Alamy stock photo.

They were equally methodical in their selection of Kitty Hawk as the test site for the full-sized Wright Flyer. The empty beach was remote; its sandy dunes could reduce damage (and injuries) in a crash. And the high coastal winds could help increase lift as their flimsy plane took off. After completing the first flight (figure 30), they continued to improve their planes and developed one of the first airplane-manufacturing companies in the world.

Intelligent iteration was the key to their early success. The Wrights studied the work of previous inventors and then developed a scientific strategy by which they could test their designs and make improvements. Because they combined analysis with inspiration, every inventor they researched, and each prototype they made, helped to advance their ideas. As a result, they succeeded while many of their better-funded rivals failed.

Figure 30. Photo of the Wright Brothers' 1903 Flight at Kitty Hawk. Orville is flying the plane; Wilbur is shown alongside. Source: Library of Congress, Prints and Photographs Division. Public domain.

IDENTIFYING AND OVERCOMING OBSTACLES

If Your Project Is Truly Inventive, Problems Will Certainly Arise. What Can You Do?

Rationale: Imagine you are learning a new athletic skill, such as dribbling a basketball or hitting an archery target. Or remember your initial attempts to play a musical instrument, follow a complex recipe, or give an oral presentation in class. In all cases, our initial efforts tend to be pretty dreadful. The ball bounces out of our hands, we miss the target completely, the food tastes terrible, we stumble through our presentation. Likewise, if your capstone project really requires you to stretch, it is inevitable that you will encounter problems along the way. So, this exercise may help you fight your way out of the quicksand.

Three Project-Saving Strategies: For the sake of this exercise, we will focus on three key words: *identify, communicate,* and *process.*

The first step in overcoming an obstacle is to identify it accurately. For example, let's say you want to sell more widgets, so you decide to

improve your online marketing. However, an improved website won't solve the problem if your widgets are hard to use or easily broken. In that case, you have failed to identify the real problem (a faulty product) and thus pursued an ineffective solution (an improved website). Improving the product and *then* expanding your marketing is a better approach.

Here's another example: You seem to be the only one doing any significant work for the organization you have developed or for the collaborative team you have joined. No matter how hard you work, the organization doesn't seem to make much progress. Are the other members of the team lazy, or is the real problem a lack of organizational clarity? Because you are doing so much yourself, others in the group may not understand what needs to be done or how they can contribute. In this case, clarifying each person's tasks, identifying deadlines, and then delegating responsibility may be more effective than working more and more hours yourself.

This leads us to our second key word: *communicate*. In a start-up organization or during a collaborative project, communication is often the first thing to break down! As the COVID-Central website (page 68) demonstrates, agreeing to a compelling mission from the start, identifying and distributing tasks, creating a concise and realistic series of deadlines, and meeting on a regular basis are ways to solve many organizational problems.

Identifying potential mentors is another step toward improved communication. Someone almost always knows a lot about a problem you are trying to solve or can at least provide a fresh perspective. Finding such a mentor and discussing your problem often leads to a solution and may spark an invaluable professional friendship.

Our last key word is *process*. We often focus on product innovation and overlook process innovation. The strategies that we use to run an organization can be as important as the ideas or objects we produce. While books on management can offer valuable advice, your specific approach must be aligned with your own personality and the needs of the organization you lead. How might a change in your work process help you solve a problem?

DO THIS: To increase clarity, list every obstacle you are seeking to overcome. Then, identify them by type: material, financial, interpersonal, and so forth. Are the materials you are using working badly? Are they overpriced? A web search of alternative materials or sources may solve your problem. Or does everyone on your team seem irresponsible or confused? A human relationship problem of this kind may require both individual and group meetings focused on changing the dynamics. Remember the

proverb "For someone with a hammer, every problem is a nail." Realize that every problem is not a nail and that different types of problems require different types of tools and different types of people.

To strengthen communication, review your successes and failures so far. If you are working collaboratively, meet for at least twenty minutes with each team member, one-on-one. Ask questions and solicit the team member's advice. If you are working solo and need help, seek out mentors or try talking directly with your suppliers. Email and texting can be expedient—but a face-to-face conversation can solve problems that texting cannot.

Process innovation is often more elusive than product innovation. Learning about ways that other creative thinkers have solved problems can be especially helpful. Many *TED Talks* are as inspiring as they are informative. *How I Built This*, a free podcast presented by National Public Radio, is a great source of information about entrepreneurship. *The Startup Playbook*, by David Kidder, is another eye-opener; it offers targeted and engaging profiles of innovators and entrepreneurs of many types. (This book ends with a list of recommended podcasts and readings: see page 121.)

Self-Reflection 4: Capstone Project

What have you accomplished? What have you learned? What will you do differently next time?

Rationale: Remember that terrific trip you took four years ago or an amazing concert you attended last year? If you kept a record of either one, the experiences are fairly easy to recall. However, memories quickly fade if no record exists.

Creating a self-reflection on your capstone is even more important. This commentary helps you to review the choices you made, recall the obstacles you had to overcome, and assess what you accomplished. All of this information will help you a lot when you tackle your next major assignment! The following questions can get you started.

Sequence of Events: How did the project actually unfold? What problems occurred? What adjustments were made?

Analysis: What strategies can you retain for future projects? What strategies can you modify or eliminate? Was the collaborative work generally effective—or generally frustrating? What adjustments would you make in

the future? What did you learn, and what do you need to learn in order to tackle bigger projects?

Future Opportunities: Did you identify any mentors or collaborators with whom you might work in the future? Who were they, and how can you build on those relationships? Did you come up with any ideas for future projects? If so, list them.

Conclusions: How were you able to use ideas from the entire course to strengthen your capstone project? How might work on this project inform work in your other courses?

Module 7

INNOVATOR INSIGHTS

Case histories and interviews can give us insight into initiatives others have launched as well as the problems they encountered and the solutions they devised. So, this section includes interviews with innovators in a wide variety of fields. My questions are bolded; innovator responses are in regular type. Each person interviewed tells a compelling story and gives down-to-earth advice. As you read, consider the following:

- What initially motivated each innovator?

- What creative solutions did the innovators apply to the problems they encountered?

- What was each innovator's most valuable resource?

- Which aspects of each story most resonate for you? Why?

BUILDING A BETTER BUSINESS

Mark Breen is a senior economic development officer and project leader for the Catalyst Innovation Program in Saint John, New Brunswick, Canada. In this capacity, he helps guide regional companies seeking to transform their cultures in order to build highly creative problem-solving organizations. This interview focuses on a system called Simplexity, which helps us identify both our imaginative and analytical capabilities and embrace multiple skills as we move from ideation into action. To date, Breen has successfully used this process with over fifty companies and organizations in New Brunswick.

How did you get interested in innovation and creativity?
I began college as an engineering major. Optimizing results is at the heart of this field and remains a significant aspect of my work. However, I soon realized that I was most interested in exploring new challenges and

generating new ideas, and I switched to a major in psychology. In my current work, I combine insights into motivation and effective marketing with a commitment to practical action.

In one of your online interviews, you suggest that creativity is the generative process that precedes innovation. Can you expand or explain that idea?

Yes. I see innovation as applied creativity. Through creativity, we generate options and conceptualize solutions; through innovation, we implement new services and processes and manufacture new products. It's not enough to just generate ideas; we also need to be able to decide what we will focus on and what we won't. Innovation is all about making good decisions.

I understand you use the eight-step Simplexity process in your work. What is it?

This approach was developed by my mentor, Dr. Min Basadur, president of Basadur Applied Creativity and professor emeritus of Organizational Behavior and Innovation at McMaster University. Simplexity provides my clients with a method that they can learn and apply quickly. For more detail, you can visit the *Applied Creativity* website: https://www.basadur. com/simplexity/.

Problem formulation dominates the first three steps.

Step 1: *Problem finding* literally consists of identifying or anticipating problems and opportunities. The result is a continuous flow between past, present, and future problems, changes to address, and opportunities for improvement within an organization. Innovative people and organizations don't wait for problems—they go out and find good problems to solve. Initially, neither the problem nor the solution is clear: all we have are fuzzy situations that seem to have strong potential for further development.

Step 2: *Fact finding* consists of deferring judgement and actively gathering information that helps better define the fuzzy situation we identified in step 1. This effort sets the stage for step 3.

Step 3: *Problem definition* consists of using divergence to convert key facts into a wide variety of creative "How might we?" questions. Finding the right question sets us up for finding the right answer. This seems obvious but actually requires serious work.

In the next two steps, we begin to grapple with possible solutions.

Step 4: *Idea finding* consists of deferring judgement while creating a large number of potential solutions to the target problem. Converging on a smaller number of potentially good solutions comes next. Idea finding is easy if the group did a good job in step 3.

Step 5: *Evaluation and Selection* requires careful critical thinking. We begin by generating a wide variety of criteria we might use in making an unbiased and accurate evaluation of the potential solutions. We then select and apply the most significant to the problem at hand.

The final three stages recognize that problem solving does not end with the development of a good solution. Unless the solution is skillfully prepared for implementation, and the implementation is skillfully executed, the process will fail. We focus on finding ways to gain support for a proposed change, building broad-based commitment, tailoring the solution to match the situation, and following up to ensure the change sticks and thus persists over time.

Step 6: *Planning* involves thinking up a sequence of specific actions that will lead to a successful adoption of the new solution.

Step 7: *Gaining acceptance* recognizes that the best laid plans can be scuttled by resistance to the changes involved. When people see that the solution benefits them and that potential problems caused by the solution can be minimized, they more readily embrace change.

Step 8: *Taking action* recognizes that actions speak louder than words. No matter how carefully thought out the steps may be, nothing will move forward until we "Get on with it!" Adjustments can then be made based on actual results.

Simplexity has a lot in common with design thinking, which is a very hot topic in education in the United States. Both processes emphasize the importance of problem definition, rely on extensive research, and alternate between divergent and convergent thinking.

Yes! Both design thinking and Simplexity recognize the importance of psychology. We must clearly identify stakeholders and understand client needs. No matter how great a product or process may be on paper, it will fail if it doesn't improve someone's life. A key element of Simplexity is understanding how everyone on the team prefers to solve problems and how best to integrate those styles. Based on Basadur's research, we can identify four problem-solving styles by the people who embrace them:

- Generator—creates options in the form of new possibilities or new problems that might be solved and new opportunities that might be capitalized on

- Conceptualizer—creates options in the form of alternate ways to understand and define a problem or opportunity and good ideas that help solve it

- Optimizer—creates options in the form of ways to get an idea to work in practice and uncover all the factors that go into a successful implementation plan

- Implementor—creates options in the form of actions that get results and gain acceptance for implementing a change or new idea

Your approach embraces many facets of innovation, which is also apparent on your organization's website (figure 31).
Yes. Effective innovation requires skillful integration of product development, production, marketing, workforce development, finance, and often much more. That is what makes my job so exciting. It is endlessly challenging and stimulating.

We often associate creativity with the arts yet underestimate the role it plays in business.
Absolutely. Creativity isn't really a function of talent or produced by an occasional flash of genius. It is about careful observation, insightful analysis, synthesis, empathy, and persistence! Creative processes (such as Simplexity and design thinking) can be applied to all kinds of problem seeking and problem solving and can equip students for professional and personal success throughout their lives.

Figure 31. Screenshot from Economic Development Greater Saint John website. This site includes information on the wide variety of programs offered. Source: Economic Development Saint John, https://edgsj.com/en/entrepreneur-development#starting-a-business.

Mark Breen's Down-to-Earth Advice

- *Dream big—and then focus on developing practical solutions.* Intention without effective action accomplishes nothing.

- *When working on a project, balance action with assessment.* Rushing ahead at a hundred miles an hour is useless if you are headed in the wrong direction.

- *When in doubt, return to your initial motivation and intended audience.* Are your decisions truly advancing your intentions and improving life for your client? It is easy to add fancy new products or features that do neither and drain time and energy in the process.

- *Remain optimistic.* Every entrepreneur runs into roadblocks and makes bad decisions. Those who thrive assess the situation, make corrections, and move on!

PROBLEM SOLVING FOR SCIENCE STUDENTS

Ian Fogarty began his career as a graduate research chemist in New Mexico, designing anticancer radiopharmaceuticals. More recently, Ian's innovations have primarily been in scientific education, and his advice on educational technology applications is sought by companies across Canada. From the very beginning of his career, Ian has also combined his love of science with a humanistic orientation that emphasizes critical thinking, communication, collaboration, creativity, and global citizenship.

Your degrees are in chemistry, and you worked with NASA on Mars research early in your career. What attracts you to this discipline?
My father was a biology teacher, and I always loved science. In high school I found that biology required a lot of memorization, but when I switched to physics, I felt that many of the modern theories were too detached from everyday reality. So, I settled on chemistry, which requires substantial math as a means to create elegant solutions to complex problems. Chemistry lets me exercise all parts of my brain. Just as a triathlete is good in three sports rather than expert in one, so the chemist must combine foundational knowledge, understanding of problem-solving processes, and creativity.

We tend to teach as we were taught. What approach did your high school chemistry teachers use?

I went to a terrific high school full of great teachers. The chemistry teachers were especially inspiring. The foundational knowledge they offered served as a means to an end, rather than an end in itself. We learned the material so that we could solve problems, not just pass tests.

What aspects of your own teaching are derived from their methods?
I've very deliberately expanded on their approach in my own teaching. Everything we do is as experiential as possible. I lecture when necessary, but as soon as my students master the basics, I give them difficult problems to solve. The problem-solving process is crucial. Rather than show them the easiest solution to a narrowly defined problem, I encourage them to work through more complex processes that can be applied to many problems. I warn them ahead of time that they will probably get frustrated as a result, and then I swoop in with help when they really need it.

This reminds me of a friend who laboriously mastered a specific piece on the piano but had to start over in order to learn any other piece. He lacked the foundational knowledge needed to transfer his knowledge from one piece of music to another.
Yes. Simply learning the most efficient way to solve one type of problem can shortchange long-term understanding. Students need to grapple with complex puzzles; that is what scientists do! And to a substantial degree, the problem-solving strategies they learn through science can be applied to other disciplines as well. They understand that by working sequentially, they can tackle and solve all kinds of difficult problems.

For over twenty years, you have taught chemistry, physics, and a general science course in Canada. Why did you shift from working as a scientist to a career in education?
When I was working on my master's degree in New Mexico, I volunteered to coach wrestling at the local high school. Thanks to a couple of key coaches, wrestling had been very important to me as a teenager, and I just felt I should give back to the community in which I lived. I wound up working with a group of undocumented teens from immigrant families. They were highly motivated, but their possibilities were greatly limited by their personal situations. When our small school was ranked third in the state for wrestling, a group of these kids were able to attend college on athletic scholarships. All of them agreed in saying, "We are going to college because of wrestling, but we are going for an education." And then one of them noted that he couldn't save his whole family, but he could save himself. The day after that conversation, I applied to an education degree program.

Through your past fifteen years of work with Shad (an international residential program for outstanding high school students), you've also become a creativity catalyst for up-and-coming leaders. What does the Shad program provide to students?

With no tests or grades, Shad gives students time and space to explore unfamiliar fields and to embrace failure as a natural aspect of learning. It also emphasizes sustained collaboration. Because the team must work together, one outstanding student can't simply take over and solve a problem single-handedly.

Even as fourteen- to seventeen-year-olds, these amazing students have often attained a high level of mastery in one field. A student may self-identify as a physics nerd, an athlete, a musician. But the most complex problems don't live in isolation, within a single discipline. To address them effectively, we must combine both the knowledge and the problem-solving processes used in many fields.

What do you gain from your work with Shad?

It gives me room to play! Even the most innovative high school courses must cover a certain amount of content in a predictable way. To progress in the academic world, even the most inventive student must pass various tests. Since Shad students arrive with good foundational knowledge in at least one discipline, and since there are no grades, we can all focus on inquiry-driven teaching and learning. Neither the students nor I really know the end point when we begin the journey. We are all explorers.

Tell us about Current Generation.

Current Generation is an after-school program that focuses on solving real-world problems. Let's start with the organization's mission, keeping in mind that STEAM stands for science, technology, engineering, art, and mathematics:

- to inspire this generation of students to use their learning to make a difference in the world and simultaneously learn STEAM disciplines in transdisciplinary projects

- to build authentic relationships between students and their global peers

- to create a movement in which students all over the globe use STEAM to solve real problems for real people

You can read our full vision statement and get extensive updates at https://www.currentgeneration.org/.

How did this program get started?

This program really took off when we heard from a student who made a service trip to the Dominican Republic. Hallie and Maria, two terrific students in a small village there, didn't have access to electricity and so couldn't study at night. Candles didn't emit enough light and were dangerous to use; kerosene lamps were expensive to run and filled their homes with fumes. Happily, we were just getting started on a unit about electricity. We now had a compelling reason to do the experiments and make the models: we had to help Hallie and Maria get the light they needed! This raised the stakes: real people would be impacted by the work we did (see figures 32 and 33).

Figure 32. Constructing a lighting device, Current Generation project. Student work alternated between idea generation, careful construction, and product testing. Source: Ian Fogarty.

Figure 33. Experimental wrist light, Current Generation project. Source: Ian Fogarty.

Since then, we've been able to report on this and other projects at conferences around the world, including Colorado, New Jersey, and Italy. To raise money for these trips, students had to write professional-quality letters to sponsors and follow up with reports on the results. One interesting outcome is that Current Generation has attracted many girls to engineering. Rather than viewing it as a distant, male-dominated field, they see engineering as a way to really help people.

Connections between your work as a scientist and as an educator seem crucial. Taking it step by step, what did you learn from your four years as a scientist?
I was amazed to find that I could tackle and potentially solve any problem that interested me. Anything I was curious about could become the springboard for an experiment. That said, I also learned the importance of being proactive. Almost any substantial experiment requires funding, building a research team, and installing appropriate equipment.

How did this affect your teaching?
I approach just about everything as an ongoing experiment. These days, traditional research into educational methods can't always keep up with changing conditions on the ground. So, rather than simply embracing or rejecting a new approach, I run it as an experiment. The results are often surprising. I didn't expect the flipped classroom to work—but actually found it quite effective, especially with shy students who were unlikely to speak up in class.

Any further connections between your approaches as a scientist and as an educator?
In my classes, we start with curiosity, focus on process, and go into fewer problems in greater depth than in other similar classes. In the short term, my students may seem less prepared for the next level of work than some of their peers. In the longer term, their problem-solving skills greatly strengthen their work, even in fields such as business or literature.

Taking it further, what qualities do you most want your students to embody?
I want them to walk through the world with heightened awareness and an ability to take action: as participants, not bystanders. I'm reminded of the Goethe quotation: "Knowing is not enough; we must apply. Being willing is not enough; we must do."

Ian Fogarty's Down-to-Earth Advice

- *Learn each problem-solving process as thoroughly as you can.* When you really understand the process, you can solve all kinds of problems.

- *Recognize that the ability to work collaboratively will really pay off professionally.* The bigger the problem, the greater the need for teamwork.

- *Develop your distinctive insights and abilities—and celebrate insights and abilities of others.* Everyone has something important to contribute.

AN INTERDISCIPLINARY APPROACH IN MEDICINE

Dr. Emily Pritchard works with faculty, tech start-ups, and students to innovate and translate new technologies and research in order to improve health and quality of life. She holds a PhD in biomedical engineering and has completed research projects at the Oak Ridge National Laboratory and the Cornell Nanoscale Facility. Pritchard is also a faculty associate of the Jim Moran School of Entrepreneurship, where she teaches biomedical innovation and entrepreneurship and founded the FSU-Mayo Clinic Biomedical Entrepreneurship Certificate Program. She is also a faculty affiliate of the Institute for Successful Longevity and cofounder of the International Genetically Engineered Machine team, both at Florida State University.

You always emphasize the crucial connections between design thinking and human-centered design. Can you elaborate?
Design thinking embraces an empathetic mindset and provides a methodology to ideate effectively and reach conclusions efficiently. For me, human-centered design is the driver behind this methodology. At every stage in the process, we must refocus on the importance of the people that an invention or idea will serve. Urgency is combined with empathy so that the process moves forward briskly while retaining the vital human connection.

How did you learn this methodology?
I took an online course in human-centered design that was offered by IDEO (a renowned design firm based in San Francisco) in partnership with +Acumen (a nonprofit social-change education program led by financial nonprofit Acumen). I loved this course and followed up with training in Stanford's d.school design-thinking methodology. I've also learned by doing, which is

another core concept. I built design thinking into my new biodesign-engineering class at the FAMU-FSU College of Engineering, workshops around the university with diverse stakeholders, and, more recently, incorporated it into new courses I'm building in medical entrepreneurship.

Design thinking is often cited as a way to solve "wicked" problems: these typically present incomplete, contradictory, and shifting requirements that are difficult to understand and impossible to solve in a linear way. Please comment.

I'm cautious about the word *wicked*. Solving a complex, contradictory, and shifting problem is actually fascinating to me and the other scientists I know. Let's consider the challenges in medicine. The human body presents a collection of systems that are intertwined biologically, chemically, electrically, mechanically, and psychologically. Furthermore, we have to design our diagnostics or interventions for use by patients at home or via a healthcare system that is astonishingly complicated. We can't just walk away in frustration; lives are at stake.

Describing "clock" and "cloud" problems may be more useful. A clock records time clearly and methodically. When it breaks, we know how to fix it, even though the mechanism may be complex. A cloud can envelop us in damp and disorienting mist and continually changes in size and direction. Thus, clock problems tend to be more linear and straightforward, while cloud problems tend to be more elusive and harder to define. Design-thinking methodology can be applied to either type but is especially helpful when we are surrounded by uncertainty.

What are some of the benefits of design thinking when tackling such problems?

- *It is purposeful.* Clear problem definition is highly valued. And asking the right questions pushes the process forward. When we get lost, we return to our mission, so to speak.

- *It encourages an interdisciplinary approach.* Interdisciplinary teams are essential when solving medical problems. Scientists refine our understanding of underlying disease mechanisms. Engineers bring new measurement methods and enhanced analysis. Clinicians offer deep insight into processes and treatments. Entrepreneurs create new business models and bring innovative products and services to market. Without the combination of scientific research, engineering expertise, clinical insights, and entrepreneurial optimism and energy, great ideas could get derailed and even lost.

- *It is iterative.* Rather than simply trying to think our way to a solution, we rapid prototype and learn from our failures. We seek to fail early, adjust course, and keep going.

- *Critical analysis is honest and frequent.* Rather than taking offense when a colleague notes a weakness in our design, we embrace any informed input. And we check with our clients early and often. This may sound inefficient, but, in reality, we save significant time and effort by not going too far down the wrong path.

- *It combines a methodical framework with necessary flexibility.* We can't just forward march in lockstep; this won't work when we are solving cloudy problems. At the same time, we need some structure to avoid getting lost in the fog.

- *It provides a framework for communication.* We each tend to have our own jargon, especially in highly specialized medical disciplines, engineering, and computer science. Practicing how to communicate to those outside our fields forces us to distill each idea down to its essential meaning, which can benefit the speaker as well as the listener.

- *It helps us keep our eye on the ball.* Design thinking is human centered. We are successful only when we create something that actually helps someone.

Please describe how these attributes contributed to one of your projects.

In 2004, I was involved in a collaborative study with the University of Tennessee Department of Anthropology to study bone shape. In this academic investigation, we were able to use all kinds of emerging tools at the University of Tennessee and Oak Ridge National Lab, including computational-modeling, high-resolution CT scanning, and custom statistical models.

Design thinking then helped me expand this information and apply it to medicine. In talking with patients from a different study who had received knee implants, I learned that more women than men undergo total knee replacement. Women also undergo the majority of knee revision surgeries, in which a total knee replacement is torn out and a new one installed. This is a painful, long process and uses a lot of bone which never grows back.

Here are some of the ways design thinking led to a medical solution:

Figure 34. Kneecap diagram, 2020. Understanding the structure of the female knee led to improvements in knee replacement surgery. Source: Emily Pritchard.

- *Problem definition and initial research.* Why were more women affected than men? Starting with the patients, I dug into the clinical data and interviewed numerous orthopedic surgeons.

- *Interdisciplinary perspectives.* The team that tackled this problem represented medicine, business, and the FDA [Food and Drug Administration]. It was spread out across Tennessee, Ohio, and Indiana.

- *Deeper research.* What was causing the problem in the first place, and how were existing artificial knees failing women patients? We found that size was a major factor, and nuanced shape differences distinguished female from male anatomy.

- *Potential solutions.* Once we understood that simply changing to a smaller size didn't make an implant fit a woman, we could propose and prototype potential solutions that addressed female shape (figure 34).

- *Iteration.* Using prototypes, we identified nuances in knee shapes and refined a design with the Zimmer product-development team.

- *Implementation.* In October of 2005, I wrote a paper describing the problem to the CEO of Zimmer, Ray Elliott, and Chief Scientific Officer Dr. Cheryl Blanchard. In the paper, I scientifically defined the problem and proposed a potential solution. By March 2006, the implant design was debuted at the American Academy of Orthopedic Surgeons' annual meeting. The design was soon approved by the FDA and has been used for tens of thousands of women since.

How do the exercises in this book relate to design thinking?
These exercises use many of the same strategies and provide a great foundation to launch an initial understanding of innovation concepts. Students who read this book and complete these exercises will know a lot about ideation and implementation, which is useful in many situations. A full design-thinking course can provide greater detail and hands-on experience.

Emily Pritchard's Down-to-Earth Advice

- *Incorporate diverse voices on your design-thinking team.* Your stakeholders will be from different business units, and the ways the people you serve look and think may differ from the ways you do. Voices of people with different backgrounds and perspectives will challenge your design process, ultimately resulting in more innovative solutions.

- *Get feedback early and often.* Create a culture that expects and values feedback, even if you don't take action on every suggestion your team receives.

- *Remember that final solutions may look different from those you initially imagined.* That's a feature of design thinking, not a bug!

- *Keep your goal in mind.* Whom are you serving and why? Let this be a guiding star throughout your design process.

HARD FACTS AND SLIPPERY FICTIONS

Jeremy Thomas Gilmer (figure 35) was born in New Brunswick, Canada and spent his first years in Nigeria. He has since lived and worked in over forty countries, including Argentina, Peru, Angola, and the Democratic Republic of the Congo. He primarily manages international engineering projects for a variety of purposes, including mining, oil and gas, and very large civil projects. He is also an avid short-story writer.

In a recent email, you noted that you are working fifteen-hour days during your current engineering project in Brazil. How do you find time to write?
Actually, I must make time to write. In 2019, I took three months off from my day job in order to concentrate on writing and got a series of short stories well on its way. Previously, I did an obscene amount of

Figure 35. Jeremy Thomas Gilmer inspecting an engineering site. Source: Jeremy Gilmer.

writing while waiting in airports or sitting on planes! Writing is something I have to do. It helps me make sense of the world around me and understand myself. Having traveled so extensively and experienced so many countries and cultures, I have a wealth of experiences on which to draw. Through writing, I often unearth unexpected truths about past events and new perspectives on current concerns. For me, the process of writing is as much about learning as creating.

Is your work in engineering beneficial to your work as a writer?
Actually, it is—and not simply because it has provided me with rich experiences and a steady income. Attention to detail is an essential part of engineering and mining; our actions can literally affect lives for decades. Engineers work with complex problems that have real consequences.

By inclination and through experience, I've become hyperattentive. For example, if we return to this library next week, I will notice that

a book has been added to that shelf behind you. Noticing details and considering consequences are both great advantages in my writing. Line by line, sentence by sentence—I try to give each the same weight as I give to my engineering work.

We often are urged to think outside the box. But choreographer Twyla Tharp has emphasized the importance of thinking *inside* the box—that is, determining the parameters of a project and exploring them deeply. Comments?

Before doing either, I think writers need a deep knowledge of the history of writing—from *Gilgamesh* to *Moby Dick* to *The Handmaid's Tale*. We need to understand deeply the bricks and mortar of literature. In my guest lectures, I always encourage students to read everything—and then encourage them to try everything in their own work. With this approach, the attempts that fail can be discarded, and the one finally chosen is likely to be more powerful.

What are some of the books, stories, or poems you have found most transformative? Why?

Joyce's "Araby" (from *Dubliners*) is my favorite short story; no work has grabbed me by the heart as that has. It encompasses the heart-wrenching moments of our simplest tragedies and looks at our emotional wreckage so closely. As a novelist especially, Cormac McCarthy has influenced me greatly. In *Blood Meridian* he brings so many aspects of the modern novel and modern literature to the fore in such rich language and scope. Ben Okri holds a very special place in my mind and heart. His *The Famished Road* is a work I return to every few years And, I believe just about every young writer working today has been influenced by Chimamanda Ngozi Adichie. I especially recommend her novels *Purple Hibiscus* and *Half of a Yellow Sun*, as well as all of her lectures and work as a public intellectual. Someone whose work I feel very strongly about is Colin McAdam. His novel *A Beautiful Truth* is a wonder. It is the book I've given to the greatest number of friends. The empathy, vision, and pure craft present there is, I think, almost unmatched in Canadian letters.

Is there a specific generative spark for your stories?

Images are powerful. For example, seeing a small African boy perched on the rusted brow of a freighter ship was the beginning point for one of my novels. Where has he come from? Where is he going? What does he fear? What does he love? I have an avalanche of ideas; I just need time to develop the best ones!

How important is direct experience to your writing?
We often read of actors preparing for roles by learning new skills, from archery and singing to surfing and rock climbing. As a writer, I, too, need to understand how something works and know how it feels. Ideally, I do it myself. If it is too dangerous or impossible, I talk with someone who really knows that field. Immediacy is powerful.

Creativity is a very hot topic in business and science as well as art these days. Some argue that it can be taught; others believe that it is inherent. Comments?
Being able to expand ideas widely and then to select and develop a specific idea deeply is essential. The first is often described as divergent thinking; the second is often described as convergent thinking. I think we all stand on the bank of a creative river and must step forward to dip in our cups.

A pivotal scene in the movie *Dead Poets Society* is the destruction of a page in a textbook. On that page, the author suggests that the significance of a poem's content combined with the skill of its writing are easy predictors of excellence. The teacher (played by Robin Williams) rejects this premise and even has the students tear out the page. He argues that poetry, unlike engineering, is elusive, even magical. Comments?
I love that scene. In engineering, the foundation must be solid, or lives may be lost. However, in art, we can use *mist* as the foundation for ideas. Shifts in perspective and hidden possibilities can enrich a narrative. The most improbable ideas can generate the most astonishing writing—think of Italo Calvino or José Saramago. The magic tends to occur when the text is not predictable!

So, if we cannot simply graph excellence in literature, what do we seek? What distinguishes merely skillful writing from marvelous writing?
Empathy is at the core of my writing. The story exists for the reader to feel the characters and their settings—to bleed with them, laugh with them, be lost with them. That journey, the shared journey with the characters, even when many of the mechanics of the struggle may be hidden from the reader, is the core of what I try to achieve as a writer.

Jeremy Thomas Gilmer's Down-to-Earth Advice

- *Cultivate attentiveness.* Every moment of every day offers a feast for the eyes and the mind if we are truly observant.

- *Read widely and regularly*. The best writers tend to be avid readers. Especially seek stories that are not set within your own culture.

- *Be prepared to revise, revise, revise*. Revisions help us refine our ideas as well as our sentences.

- *Embrace uncertainty*. We learn the most when we don't have the answers.

- *Beginnings and endings are powerful—in any field*. The way I conduct myself at the beginning of an engineering project can facilitate months of productive work. Likewise, the way I start a short story sets the stage for every sentence that follows.

FROM BUILDING HOUSING TO REBUILDING LIVES

Jill Pable is a professor in the Interior Architecture & Design Department at Florida State University and a fellow and past national president of the Interior Design Educators Council. Her research focuses on the design of environments for the disadvantaged, and she is the originator of the Design Resources for Homelessness initiative, a research-informed non-profit online information source for architectural designers and organizations creating environments for people recovering from homelessness. She was included in the DesignIntelligence list of 30 Most Admired Design Educators in the United States in 2015.

How did you get interested in interior architecture and design?
I began college as a music major but soon realized that I lacked the single-minded dedication that this field requires. I then tried biology, geography, and meteorology before winding up in restaurant management. Through a required restaurant design course, I found my real passion and shifted to housing and interior design. I love this field's altruistic orientation and find each design fresh and distinctively challenging. Teaching in this field is even more fulfilling.

How did you become interested in housing for disadvantaged populations?
I taught at Sacramento State University in California for five years. Because that state has a large homeless population, I realized that I could explore this issue with my students, as a way to connect their

coursework to real-world people and projects. The students interviewed homeless people, researched existing options, created new designs, and presented reports on their findings. It was the first time I saw students weep during oral presentations. They saw how real and impactful this issue is to those involved. This is an urgent problem that is too often overlooked. As a result, this form of housing has been my main focus for the past fifteen years.

Dissatisfaction with the status quo often drives innovation, it seems to me. Please comment.
That certainly applies to this type of housing. Shelters are often repurposed rather than being built specifically to meet client needs. They may be warehouses with low ceilings and no windows. People often share rooms with thirty or forty strangers, and video surveillance is typical. Privacy is pretty much nonexistent, and lack of storage space results in a lot of clutter. While policies vary amongst shelter-providing organizations, many facilities are bland, and some are frightening, which can discourage people from staying at them.

The need for temporary housing is tremendous, but budgets are limited, project completion schedules are tight, staffs are often overwhelmed, and the politics are complex. Add the substance abuse, trauma, and mental illness problems that plague many residents, plus the limited training of architects and designers in the area of homeless housing, and the problem becomes a perfect storm.

What changes have you and others begun to implement?
First impressions are important. After bad experiences elsewhere, a person may enter a shelter very cautiously. Using soft lighting that is directed upward rather than harsh lighting that is aimed downward helps. Painting bunk-bed frames a color other than black is important: black is what you see in prisons. Matching linens and a place to write your name on your home—even if it is simply a bed—help introduce residents to each other and make them feel welcome. Small, inexpensive features can make a big difference. As shown in figure 36, special attention should even be paid to restrooms.

With many needs and tight budgets, how do you begin?
My colleagues and I have been working to understand the fundamental, core human needs that people seek to fulfill when they are in crisis and require temporary or permanent housing. With the help of established housing standards and key principles of trauma-informed care, we have developed the following list:

Figure 36. Restroom, Kearney Center, Tallahassee, Florida. Soft lighting, warm color, and encouraging text were used to create an inviting environment. Source: Jill B. Pable.

1. *Sense of safety and security*—feeling safe, versus feeling fear

2. *Sense of organization or order*—feeling like things are arranged so that you can be productive and think straight, versus things are disorganized so that you feel chaotic or on edge

3. *Feeling in control or empowered*—feeling like you have the ability to direct your life, versus feeling like others are controlling how you live your life

4. *Feeling there is fairness*—feeling like everyone is treated the same way, versus feeling like some have priority over others

5. *Maintaining or building self-esteem*—feeling like you are a person of worth and can make progress, versus feeling like you will never succeed

6. *Managing stress*—feeling nervous or preoccupied, versus feeling relaxed and comfortable

7. *Being positively acknowledged by others*—feeling like others respect and notice you, versus feeling like others ignore you or see you as a problem or burden

8. *Being creative or expressing myself*—having the chance, versus not, to express yourself or experiment with ideas or objects

Based on these criteria, we are developing a checklist scoring system so that a built or unbuilt design might be reviewed, thus helping us prioritize improvements.

It seems that there are really three components to your work: research, sharing resources, and working directly on actual designs.
Yes. As a researcher, I work with researchers in disciplines such as architecture, social work, and psychology to understand better the needs of persons in crisis and the challenges communities face. In order to share resources, I created a nonprofit organization called Design Resources for Homelessness [http://designresourcesforhomelessness.org/], which interprets research and distributes case studies, reports on the needs of persons in crisis, and provides extensive bibliographies of practical information for use by shelter-sponsoring organizations, policy makers, and designers.

Finally, when my schedule permits, I contribute to design projects (usually for free), so that I can work directly with homeless clients and shelter-staff members.

What are the ideas behind the housing-first movement?
In the past, homeless people had to get a job before they could be placed in various types of housing. We now realize that housing them greatly improves their chances of finding a job and remaining employed. Once people are in stable housing, it can be easier to assist them with substance abuse or other hurdles.

Homelessness creates a level of emotional and material chaos that is hard for many of us to imagine. I remember the story one woman told me. She had lined up a crucial interview—but when she got ready to leave her tiny, cluttered room in the shelter, she couldn't find the slip of paper on which the address was written, and thus missed a crucial chance. As I've looked into this type of problem, I've become interested in an area of psychology called embodied cognition, which suggests that the way we think and act is deeply influenced by our physical surroundings.

Why is housing for persons who experience homelessness so important to you?

I see the physical environment as a way to improve opportunities for people's self-actualization—being as full, productive, and satisfied in life as possible. Just think of the stories and songs waiting to be written or the new theories or businesses waiting to be developed by a child who may be homeless today but could be a college graduate in ten years! Housing can truly transform lives.

Jill Pable's Down-to-Earth Advice

- *Be as prepared as possible for every meeting*. Each encounter is an opportunity for positive change, for offering helpful insights, or learning something that progresses your thinking.

- *Offer something useful to anyone you seek to engage*. Interactions are healthier when all participants benefit.

- *When you are the expert, don't arrive with a chair and a whip*. Instead, value the insights of everyone in the room, rather than thinking that somehow you have all the answers.

- *Put yourself in the client's position*. Empathy is the key to successful design—whether your client has a million dollars or ten. Especially when speaking with people in need, try for one part talking, three parts listening, and four parts understanding.

- *Keep your eye on the ball*. Don't lose sight of the main objective—that is, the self-realization of everyone, including staff members, at homeless shelters. When it comes to building healthy communities, we are all in this together!

STORYTELLING AND SOCIAL CHANGE

Producer/director/writer Liz Canner is an award-winning filmmaker and multimedia artist who creates documentaries and interactive media projects intended to inspire positive social change. Her critically acclaimed feature-length documentary *Orgasm Inc.* was a *New York Times* Critic's Pick. The documentary screened at over seventy international film festivals, was released in theaters, broadcast on television in many countries, and streamed globally on Sundance Now, Fandor, Vimeo, and Netflix. Canner has received over sixty awards and grants including a Radcliffe Institute for Advanced Study Fellowship from Harvard University, a Rocke-

feller Foundation Next Generation Leadership Fellowship, and a National Endowment for the Arts grant. Visit http://www.astreamedia.org/ for the latest updates on her work.

The range of topics you have explored in the past thirty years is remarkable. Using candid interviews with officers and their supervisors, *State of Emergency: Inside the LAPD* [1993] deals with the causes and effects of police brutality in Los Angeles. *Moving Visions* [2003] explores issues of freedom and security in the aftermath of the 9/11 attacks. *Orgasm, Inc.* deals with trials for an unnecessary and potentially dangerous drug. How do you choose your projects?
To a great degree, it seems that the projects choose me. I become passionate about an issue based on the environmental degradation I witness, the stories I hear, the books I read. I seek out critical issues that impact our daily lives but aren't being covered in the public sphere. I tend to alternate between projects that are more locally focused and projects that are broader in scope and could reach a wider audience. Seeking to use my capabilities as a filmmaker and artist responsibly, I carefully weigh topics, audiences, and the best storytelling approach for the greatest impact.

It seems that years of research must be required before you even begin.
Yes, I often feel like I'm pursuing a PhD in the topics I tackle because of the exhaustive research I do for each project. I am extremely curious about the story behind the story—what is the root cause of the injustice? And what can be done to rectify the situation?

The more I learn, the better I can understand the motivations of those I interview. It is important to avoid simply demonizing individuals. By examining the broader cultural, historic, and economic factors that could be contributing to their behavior, I am better able to see systemic problems. For example, it is too easy to dismiss police brutality as the work of one bad apple and thus avoid examining the structural factors and changes that are really needed.

Can you briefly describe the research required for *Symphony of a City* [2001], which deals with the housing crisis in Boston, Massachusetts?
Yes. Research for that project was varied and complex. Identifying the questions that drove each stage of the research may help your readers.

- My collaborators and I first asked, "What important issues in Boston are being under-reported by the mainstream media?" When we contacted fifty community organizations and governmental departments, the housing crisis was identified by

the overwhelming majority. In one big blow, eighty thousand low-income units had become unaffordable. Homelessness had skyrocketed to over ten thousand families, and many elderly tenants were at risk of losing their homes.

- "What caused this massive change in housing security?" was our next question. Through research and conversations with housing experts, we learned that four years earlier, rent controls had been removed in Boston. This caused the price of affordable housing to rapidly rise to the market rate. Many low-income tenants now couldn't afford their homes.

- "Why were rent controls removed?" became the next question. A landlord organization was the driving force behind the change in legislation. The value of their properties had increased over time and they wanted to charge more.

- "How did it affect renters directly?" was our next question. We did quantitative research and read policy papers. Then we reached out to the fifty community groups we had originally polled and asked them to nominate people who best represented their organization's point of view. This included the landlord organization. Next, we conducted primary research through interviews. This gave us deeper and more direct insight into the impact of the crisis.

- We then asked, "How can we engage the power brokers of the city to address this issue?" We asked the organizations to nominate community leaders who could have an impact on the situation.

Essentially, the entire process was driven by curiosity. Each time we unraveled one mystery, another question arose. Throughout, we combined research into the economics, laws, and policies that drove this crisis with direct conversations with residents and the community organization that sought to serve them. A sociologist and an anthropologist who joined the project helped us understand better the implications of the information we received.

So, your films are really driven by the stories people tell. How does this direct contact with the people most involved in an issue inform your understanding and enhance the film's impact?
I am lucky to work independently. This gives me the freedom to select the stories I tell. It also gives me more time to spend with my subjects and

thus to explore deeply topics that the mainstream media overlooks. And even when I deal with mainstream subject matter, I'm not constrained by economic or political interests or advertisers. This allows me to explore more controversial subjects and add different perspectives.

It also offers me the freedom to innovate with technology so that my projects provide the viewer a new way to experience a story. This had a direct impact on *Symphony of a City* (figure 37). Instead of offering a traditional single-channel documentary, the community organizations identified eight citizens from very different walks of life. We provided a tiny video camera to each of them and then attached the cameras to their heads so they could present their point of view for a day. This group

Figure 37. Mock-up for projections, Symphony of a City, Boston, Massachusetts. Four narratives were projected onto City Hall. A mock-up showed how this would work. Source: Liz Canner.

included a homeless person, a multimillionaire landlord who had organized against rent control, and the former finance chair of the Democratic National Committee. Through the eye-view cameras, we were literally able to see the world from their very different perspectives.

The results were first presented as large-scale outdoor video projections on the facade of Boston City Hall and streamed online. Each of the participants' videos was juxtaposed with the three others so that at any given moment four stories, four lives, and four perspectives were shown. After the first night of video projection on Boston City Hall, the *Boston Globe* responded by starting a five-part investigative series on the devastation the city faced from the loss of rent control. In the end, the government allotted more money for low-income housing.

So, rather than playing your usual role as a filmmaker, it seems that you invited representatives of the Boston community to create the film.
Yes. Our eight citizen filmmakers were able to tell their own stories very directly.

Your films and projects have been shown in international film festivals and on major online platforms. They have garnered an impressive range of awards. Such public recognition is not only gratifying—it helps you raise money for your next project. But for yourself, what really constitutes a win—a project that you feel fully lived up to its potential?
I don't really think in terms of win-lose or success-failure. My team and I are motivated by curiosity and are driven to explore what is possible both technologically and story-wise. We do all we can to identify compelling questions and then to construct films that are surprising and revealing and which inspire positive change.

Liz Canner's Down-to-Earth Advice

- *Do both quantitative and qualitative research. Quantitative research* typically provides facts and numbers. It can help us identify trends and patterns. *Qualitative research* can be more personal. How did an elderly woman feel when faced with a rent bill she couldn't pay? Both are important.

- *Let your subjects determine the topic.* Research that represents the desires of subjects and communities themselves is essential. In *Symphony of a City*, we did not approach people with a preconceived issue but instead asked citizens and organizations what topics they considered important.

- *Choose the best form for your film's content. Content* is the story you are telling; *form* is the way in which the story is told. New technologies have provided artists and filmmakers with innovative interactive methods of storytelling, from individual wear-cams to virtual reality. Can you tell your story using a form that provides agency to the viewer and a new way to understand an issue?

- *Utilize compassion and nonjudgement.* In order to understand systemic issues, investigate how structures of power and reward influence individual actions. The people we are often quick to demonize may provide key perspectives for understanding the underpinnings of structural inequality.

FROM COLONY TO COLLABORATIVE COMMUNITY

Christine Nieves is the cofounder and president of Emerge Puerto Rico, a nonprofit focused on climate change leadership and community-based education. Emerge Puerto Rico expands on Proyecto de Apoyo Mutuo Mariana, a cooperative open-air kitchen and neighborhood resource Nieves cofounded following Hurricane Maria. Starting from scratch, she quickly developed the cooperative into a community oasis with the capacity to serve three hundred meals per day. Nieves and her collaborators are now shifting to sustainable development. From transforming an abandoned school building into a cultural community center to marshalling resources for individuals to launch microbusinesses, her team seeks ways to support healing from individual and collective trauma.

What is your background? How did it prepare you for your work as an entrepreneur?
My father was an engineer, with particular expertise in increasing efficiency in manufacturing. He was always thinking about ways to make almost anything work better. My mother (who could have been a poet, a playwright, or a political commentator) focused on raising her three children. Blessed with high energy, curiosity, and academic drive, I always did well in school but was bullied by other students for this, especially in middle school. I developed great tenacity and an extra measure of self-reliance as well as great empathy for the underdog.

At the University of Pennsylvania, I really blossomed. I felt more confident and was pretty much ready to try anything. Hosting a TV show at the local Telemundo station was especially valuable. In entrepreneurship, you often have to do something completely new, while projecting confidence and capability.

So, from my father I learned to question the status quo and develop alternatives, from my mother I learned a lot about service to others, and from myself I learned that determination and a willingness to take risks create unexpected opportunities.

Please tell us about your work at the Robert Wood Johnson Foundation [RWJF]. This prestigious philanthropic organization focuses fully on health.

It was amazing. I was part of a skunkworks team called Pioneer. Pioneer looks ahead a decade or two into the future in everything they fund. Its leaders are not afraid to place big bets on ideas that seem outlandish.

I got to learn about everything. As a team member of a philanthropic organization, I had the opportunity to support the work of people who were creating new systems to disrupt or replace the status quo, especially in the discovery of new drugs and treatments. I had to appreciate each system for what it was, and also be able to envision an alternative.

It seems that you and your colleagues were really passionate about the work.

Absolutely. At RWJF, we all went to work every day dedicated to changing the world. The most important lesson I learned is that vision, rather than money, is the initial entrepreneurial driver. When you have a strong vision and a solid implementation strategy, you are in a strong position to seek funding. Premature funding can lead a great vision to failure.

What is a standard definition of *entrepreneur*? Do you fit this definition?

An entrepreneur seeks to build something new either out of dissatisfaction with the old or with a clear appreciation for the ways something new can solve a customer's problem. While this often results in a new product or business, the possibilities are actually much broader. For example, I often focus on ventures that can strengthen our social equilibrium, resulting in significant improvements over time. Start-ups that empower humans to overcome their fear of each other are especially important.

To me, entrepreneurship is a tool that is best employed in the service of a broader social vision. I believe that entrepreneurs bend reality and thus, invent the future. They develop a deep understanding of the strengths and stresses in the current condition in order to reassess client needs and propose better alternatives.

You returned to Puerto Rico nine months before Hurricane Maria hit. Less than a week after the storm, you were helping to develop a

community support project that transformed your life and the lives of the people around you. Can you describe this organization?

Proyecto de Apoyo Mutuo Mariana (Project for Mutual Aid Mariana) began as a community kitchen and soon expanded to include solar-powered WIFI and electrical stations, a laundry, and even a place for children to play chess. With the physical and governmental infrastructure gone, we had to build on our own knowledge of the community, the skills community members could offer, and especially on our capacity to work together. When disasters happen, the person right in front of you is your best chance for survival.

Respect, trust, and reciprocity were the cornerstones of Proyecto de Apoyo Mutuo Mariana, and an empowered community was its result. I had left Puerto Rico at age eighteen, disgusted by the corruption, the graffiti, the trash on the beaches, and the deep cynicism about the abilities and ambitions of our people. Through the disaster and the community center we developed, I watched those false narratives collapse. I realized that we are strong, caring, and remarkably skilled at survival.

Emerge Puerto Rico is a more recent development. Leadership combined with education is a major part of this initiative. Why this combination?

Both leadership and education require us to identify and engage the rich potential in ourselves and in others. Capabilities that are ignored are resources that are lost.

For me, helping students identify their passions and strengths is just the beginning. To truly invent the future they seek, students must develop a profound belief that such a future is possible and that their contribution counts. It is so easy to let ourselves get derailed by obstacles: "I don't know enough," "I'm not smart enough," "I haven't received the necessary funding." I encourage radical responsibility, which is based on self-awareness and a commitment to effective social change. It reminds me of an idea that was first expressed in ancient times and has been repeated many times since: "If not me, then who? If not now, when?"

Students can't really learn well in a vacuum, detached from everyday life. They need to see the world as it really is, then envision the world as it could really be, and then courageously take the actions needed to truly bend the arc toward the future they seek.

Christine Nieves's Down-to-Earth Advice

- *Rather than simply focusing on personal goals and accomplishments, consider the well-being of your entire community.*

A broader community focus can benefit many people and also provides you with potential collaborators and a wider range of resources.

- *Start small and think big.* Too often we allow ourselves to be paralyzed by big problems. Through hundreds of small interventions, we can begin to move forward.

- *Realize that everyone is an expert in something.* When we identify and engage the expertise of each person, the entire community can work toward a problem's solution.

- *When in doubt, overcommunicate.* Clear, concise, and inspiring communication is the key to collaboration, especially with community-based projects. Frequent updates on even modest successes can help to inspire further action.

Self-Reflection 5: A Personal Board of Advisors

Each of the interviews in this section concluded with several pieces of down-to-earth advice. Sometimes, such practical advice is all we need to break through when we are stuck. Now, imagine that you could talk directly with any of the people I've interviewed or with comparably insightful and accomplished people in your own community. How might they help you gain perspective or devise a way out of an unproductive loop?

Well, just look around.

Every person you meet knows something that you don't know, and any empathetic listener can help you talk through a creative logjam. If you need expert advice, get to know your professors and the other students you most admire. To accomplish this, rather than always heading out the door the minute a class ends, pause occasionally to ask a follow-up question. Volunteer to help with a student or faculty project. Respond quickly and (if possible) positively when others ask for assistance. These actions help build connections, and the resulting "board of advisors" can quickly become mutually supportive.

So, for this self-reflection, identify at least four people you would like to know better, and start thinking of ways to create connections. Keep in mind that giving and taking in roughly equal measure works best. Think about what you can give as well as what you can gain from each relationship!

Module 8

FROM COURSEWORK
TO CAREER

Cultivating creativity tends to be a slow process, requiring a lot of trial and error. Unlike mastering a new computer program or learning how to repair a car, pursuing creativity can seem intangible and thus unrelated to the day-to-day demands of college classes or a job. So, how can any of us put to use the skills gained through completion of the work in this book?

Applying these creative strategies to any task or assignment is the first step. If you are in college, try to understand both the specifics of each assignment you receive and its underlying objectives. Rather than just focusing on the required word count for a paper or the technical components of a lab assignment, consider the meaning behind the actions you are taking. How might a deep understanding of the human circulatory system help you become a better nurse? In a beginning art class, why is so much time spent on observational drawing or on basic composition? Why is that research paper so important to your instructor, and what can you learn by doing it well?

The more deeply you understand the problem presented in an assignment, the more effectively you can develop a substantial solution that interests you personally. This understanding increases motivation and helps you take your work beyond the most basic level of completion. Similarly, in any job that isn't mindlessly repetitive, you generally can go beyond the bare essentials and take more initiative, if you understand deeply the problem your boss wants to solve. Proposing a radical change that is too far outside the problem parameters is not useful and rarely welcome!

Using the book as a springboard to an internship is a second step. Anyone with reasonable reading, writing, and math skills plus a strong

sense of responsibility can become a very capable intern. Interns with a greater than average capacity for analysis and the ability to suggest exciting alternative solutions are the ones who are most likely to be offered jobs once the internship ends. Again, deep understanding of the problem your boss needs to solve and the ability to expand the bandwidth of possible solutions can be extremely helpful. A special section on seeking and completing an internship appears on pages 107 to 111. Based on text written by one of my former interns, it is concise, practical, and inspiring.

This book is designed to encourage a third step: cultivating self-reliance and independent thinking, both of which require the following habits of mind.

Flexibility. Rather than using a limited number of thinking strategies regardless of their effectiveness in a specific context, the most creative thinkers use the full spectrum of brainstorming strategies described in module 3.

Commitment to critical thinking. As noted previously, generating a batch of great ideas is just one step in a creative process. We must also analyze the strengths and weaknesses of each option and choose those most worthy of further development.

Ability to combine ideas and make connections. This is important in three ways. First, the best solution to a problem often combines aspects of several earlier ideas. Second, many great ideas evolve from existing ideas. Being able to retain the best qualities of the existing idea and add improvements can lead to a stronger solution. Third, you can often use aspects of your past experiences to address a current challenge. Throughout this book, we have stopped to reflect on the meaning of each exercise and ways to improve performance. This method was designed to help you understand what you have learned and how it can apply to problems you tackle in the future.

Incremental excellence. Like the spark from which a campfire is built, ideas generally start small and then must be fed the right fuel. Through effective iterations, any project can improve. If you struggle when writing a paper or preparing a presentation for a class, start early and expect to complete at least four drafts. This practice gives you the time to think about each draft and make revisions. (For example, this book went through over forty drafts and was revised substantially based on input from eight reviewers.) "Rome wasn't built in a day," and good writing very rarely occurs in the first draft.

Finally, *Creative Inquiry* was written as a springboard for self-directed action. Rather than simply reading about the creativity of other people, you have been challenged to take action yourself. The exercises

in this book were designed to help you identify and define problems needing solutions. You have been encouraged to

- use research as an essential aspect of innovation,

- identify connections between creative and critical thinking,

- develop and utilize multiple ideation techniques,

- improve an initial idea through multiple iterations,

- clearly identify and overcome obstacles, and

- connect your coursework to your career.

Value and cultivate your own distinctive and marvelous creativity, and use it to strengthen your performance in everyday life as well as your coursework!

TRIED AND TRUE INTERNSHIP STRATEGIES

by Stephanie Vivirito with editing by Mary Stewart

I served as an intern for Professor Stewart in 2015. After graduating with a bachelor's degree in English and art history from Florida State University, I got a job coordinating special programs and communication for a nonprofit organization. A year and a half later, I landed a job as media specialist for FSU's College of Communication and Information and have been in that role for the past three years. In addition to managing and producing print and digital media, coordinating public relations, and supporting college-wide events, I supervise three student interns per semester. The following advice is based on my own internships and on my experiences in supervising interns.

WHY SEEK AN INTERNSHIP?

Building professional experiences outside the classroom provides lessons directly applicable to career development. Here is a brief checklist of benefits. An internship

- applies classroom knowledge to real-world scenarios,

- provides an opportunity to learn new skills as well as current software,

- expands networking and mentorship opportunities,

- provides exposure to workplace culture and operations,

- offers time to discover unknown capabilities and interests, and

- provides a low-risk way to test drive a potential career.

WHERE CAN INTERNSHIP INFORMATION BE FOUND?

INTERNSHIP OFFICE OR CAREER CENTER

An editing internship was required for my English degree. A faculty member coordinated internship applications and provided examples of successful internships pursued by previous students. In my on-campus internship with Professor Stewart, I copyedited and compiled research for an art history book. To get experience off-campus, I later completed an internship at a local museum as a graphic designer and marketing intern. A departmental internship office or a more general university career center or office of internships is a great place to start your search.

USING YOUR NETWORK

Many internships are filled based on networks rather than job postings. Talking to classmates, staff persons, and faculty members about careers or collaborations builds your network. Join and actively contribute to student organizations that align with your academic and personal interests. An off-campus job or volunteer work further expands your network. Then, share your professional goals with people who might help you. The people in your network can provide connections and advice when they know your interests and capabilities.

INVENTING AN INTERNSHIP

Almost every organization and individual can benefit from work with a capable and enthusiastic intern. If you have identified a company or a person with whom you want to work, research that prospect's likely needs and then propose an internship designed to meet those needs. For example, you may notice that a restaurant website is clunky and difficult to navigate. Contact the restaurant owner and say, "I'm looking to build my portfolio by completing an internship. I would love the opportunity to update your website to make it more user friendly." Even if a business hasn't previously worked with interns, its owner is likely to applaud your initiative and may offer you a transformative opportunity.

WHICH INTERNSHIP IS RIGHT FOR ME?

Consider these factors when determining whether an internship is right for you:

- *Alignment with interests.* Typically, interns seek work in situations that are closely aligned with their college major. But even if the internship isn't explicitly tied to your major, look at the projects you would be assigned and the tasks you'd be expected to complete. Does the work pique your interest and fit with your aspirations?

- *Time and energy commitment.* Given your other obligations, is the weekly time commitment realistic? Is the internship flexible enough to accommodate exam week or other demands on your energy? Is the duration long enough for you to accomplish something important yet short enough for you to have a life?

- *Cultural fit.* This is especially important if you are working with an organization. If you need a high level of direction, a loosely defined do-it-yourself internship is likely to be frustrating for you and your supervisor. If you flourish in loosely structured situations, a rigid structure may drive you crazy.

- *Potential networking.* What connections might you make with fellow interns, employees, and the clients or constituents with whom they work? Can you gain a wise mentor?

- *Learning opportunities.* How and what will the internship contribute to your existing skills and network of contacts? Will you work closely with a supervisor or existing employee?

- *Compensation.* It is extremely important to examine the compensation package of a potential internship and analyze how that matches the amount of time and work expected of you. Your university's career center or a trusted professor may be able to advise you. If you plan to pursue an unpaid internship, be sure that the experience itself is worth the work you will provide.

ONCE I START AN INTERNSHIP, HOW CAN I MAKE IT MOST VALUABLE?

Treat an internship as you would any job. Be responsible, professional, and do the best work you can, whether you are paid or not. The following

strategies improve the chances of a good experience for both the intern and the supervisor:

- *Set goals at the start.* If your internship supervisor does not lay out clear expectations at the start, have a discussion early on to establish such expectations. Be clear (and diplomatic) about what you hope to learn and what you expect to contribute. Setting clear and measurable goals and checkpoints for the internship sets you up for success.

- *Ask for feedback.* Few internships are consistently perfect for both parties; there will be some great weeks and some that are disappointing. So, don't wait until the end of your internship to ask your supervisor if you're meeting expectations. Similarly, speak up if your expectations are repeatedly not being met.

- *Take initiative.* Is your internship supervisor stressed or overwhelmed? Identify something you can do and then offer your help. Companies hire interns to help contribute fresh ideas and inventive perspectives on what they do, and your creativity and insight may be crucial, especially during a crunch time.

- *Ask questions.* Remember that internships are meant to be learning experiences. Don't be afraid to ask questions when you don't know something or need further clarification. Additionally, if there's something you'd like to pursue further or software you'd like to learn, ask your supervisor for an opportunity to enhance your learning.

- *Make connections.* Chat with your coworkers, ask a potential mentor out for a cup of coffee, join company events when possible. Creating relationships with the people at your internship will not only strengthen your professional time there; you may also foster friendships that last beyond the length of the internship.

WHAT ACTIONS SHOULD I TAKE WHEN THE INTERNSHIP ENDS?

- *Complete an exit interview.* When the internship ends, ask your supervisor for an exit interview and a written evaluation or draft letter of recommendation. This draft can easily be

revised when an actual recommendation is needed. Receiving feedback on your performance is the best way to learn and grow. Write up your own self-evaluation, based on the following questions:

- What project(s) are you most proud of?

- What is the most important thing you learned?

- How can you expand your learning further?

- Did you learn anything new about yourself?

- Is there anything throughout the internship you would've done differently?

- Is there anything about the work or culture at this internship that you would not want in a future job?

- What aspects of the internship would you like to see in your future career?

- *Send a handwritten thank you.* A handwritten note (and possibly a bouquet of fresh flowers) expresses gratitude to your internship supervisor and other employees who worked with you during the internship. This gives a grand finale to the experience.

- *Maintain your relationship with the organization.* Stay up to date on company events and accomplishments. In addition to full-time employment, there may be opportunities for you to mentor future interns at the organization.

- *Keep in touch with your connections.* One of the most important aspects of networking is maintaining communication. After your internship ends, update your supervisor and other internship contacts on your professional accomplishments.

The right internship can be exhilarating as well as educational. The experience can help you understand the rationale behind your coursework and expand your capabilities. Identifying and arranging such an internship can take time, so try to start exploring possibilities by the end of your third semester in college.

Good luck!

Appendix

TEN EASY WAYS TO STRENGTHEN YOUR WRITING

OVERALL STRUCTURE

1. Start with a Thesis Statement

thesis statement
the author describes the primary focus of the paper

Even a modest three-hundred-word essay typically begins with a **thesis statement**. In it, the author describes the primary focus of the paper: the idea that he or she will present and then support through various forms of evidence (such as specific examples or graphs). A thesis statement provides both the author and the reader with a sense of direction. Here are three examples:

- This paper will describe Houston's Contemporary Art Museum and provide an overview of its collections, programs and current exhibitions.

- In this paper, I will discuss five ways in which independent filmmaker Liz Canner uses her projects to amplify the voices of people in marginalized communities.

- In this self-reflection, I will describe my approach to each of the three warm-up exercises, identify the creative thinking skills and processes I utilized, and list four improvements I made before submitting the final project.

112

2. Use Paragraphs to Increase Impact

As you probably know, a paragraph is a basic unit in writing. Each paragraph should express a single idea. Breaking up a longer text into individual paragraphs can make it easier for the reader to follow.

To give you an idea of the effective use of paragraphs, here's a brief biographical statement. Notice that the writer includes all of the information in a single, long paragraph.

> "When I entered high school, my family began wondering about what I wanted to do with my life. 'What is Adrian's future?' 'How can he make a living?' 'What colleges should we consider?' they asked. Their concern was touching, but my own sense of direction has been clear ever since I attended a summer workshop in Yellowstone Park three years ago. I want to spend my life working in and writing about nature. I want to enter the forest with a combination of awe and an understanding of complex ecological relationships. Can trees communicate with each other? How does fire stimulate new growth? What are the relationships among animal species and between the plants and the animals? If I can share my insights and experiences with a wide range of readers, I can raise awareness of the fragility of nature and promote the preservation of entire ecosystems. I want my life to be purposeful as well as personally fulfilling, and immersion in nature seems the best way to achieve both goals."

Adrian has a good story and speaks in an engaging voice, but the writing could be stronger. Let's just see what happens when the same text is broken up into paragraphs.

> "When I entered high school, my family began wondering about what I wanted to do with my life. 'What is Adrian's future?' 'How can he make a living?' 'What colleges should we consider?' they asked.
>
> "Their concern was touching, but my own sense of direction has been clear ever since I attended a summer workshop in Yellowstone Park three years ago.
>
> "I want to spend my life working in and writing about nature. I want to enter the forest with a combination of awe and an understanding of complex ecological relationships. Can trees communicate with each other? How does fire stimulate

new growth? What are the relationships among animal species and between the plants and the animals?

"If I can share my insights and experiences with a wide range of readers, I can raise awareness of the fragility of nature and promote the preservation of entire ecosystems. I want my life to be purposeful as well as personally fulfilling, and immersion in nature seems the best way to achieve both goals."

In the first version, the reader confronts a wall of words. The second version presents the information in smaller, more inviting chunks. Each paragraph now has a clear beginning, middle, and end. Like a speaker who pauses and changes volume for emphasis, the paragraph structure breaks the text into four easily readable parts.

Also note that each paragraph expresses an individual idea or step in Adrian's story:

1. The first paragraph expresses Adrian's family's concerns about his life goals.

2. The second paragraph answers this concern with Adrian's clear sense of direction.

3. The third paragraph describes Adrian's questions and motivations.

4. The fourth paragraph provides Adrian's ultimate goals in pursuing this career.

3. Support Your Ideas with Examples

Generally, use at least two or three specific examples to support the points you wish to make. The value of this practice is especially apparent in Adrian's third paragraph, which lays out a series of questions he wants to answer:

• Can trees communicate with each other?

• How does fire stimulate new growth?

• What are the relationships among animal species and between the plants and the animals?

Generalities fill your paper with fog, while specifics make your writing memorable and your ideas concrete.

4. Reach a Conclusion

Writing is like a train on a journey. You start by heading somewhere as you depart the station. Like the cars on a train, each paragraph builds the story and connects to the preceding and following car, creating the overall structure. At the end of the journey, the train arrives at a destination. For your self-reflections, the thesis statement might present the purpose of your paper, the first paragraph might describe your initial understanding of the assignment, the next few paragraphs might describe how the assignments developed, and the conclusion might describe what you have learned as a result.

WRITING STYLE

5. Be Concise

Choose the most direct, easy-to-understand words when writing your paper, rather than "showing off" by using fancy terms. For an extreme example, just imagine a puffed-up, pretentious person stating, "In order to facilitate my habitual need for participating in our consumer society, I traveled forthwith to a local boutique to purchase a freshly minted, and uniquely stylish outfit." What rubbish! In most cases, it would be better simply to say, "I went to the clothing store to buy an attractive new dress."

6. Be Correct

English is a tricky language, replete with words that sound the same but mean completely different things. Take *peek*, *peak*, and *pique*, for example. They all sound the same but are used differently: *I peeked out the window at the bear. I climbed the mountain peak. The lecture piqued my interest.* Or how about *their*, *they're*, and *there*? *Their dog is friendly. They're going to the beach. Once there, they will play volleyball.*

 When in doubt, check it out!

7. Use an Active Rather Than a Passive Voice

In a sentence written in the active voice, the subject of the sentence performs the action. In a sentence written in the passive voice, the subject receives the action. Here's a very simple example: *Active*: The lion bit the man. *Passive*: The man was bitten by the lion. While there are times

when the passive voice is effective, the active voice tends to be more emphatic and direct. Consider these examples:

- Passive: "A selection of six figures from Chinese history, both fictitious and historical, will be investigated as morally challenged protagonists through a series of short stories, each of which will be supplemented by at least two original illustrations directly assisting the text."

- Active: "Through my short stories, I will present six pivotal figures from Chinese history as morally challenged protagonists. I will supplement each story with at least two original illustrations embedded in the text."

8. Short Sentences Are Easier to Follow Than Long Ones

Reread #7. Which version makes more sense?

9. Build Your Vocabulary

There are a number of specific terms used in every discipline that are essential to effective writing. For example, in art, color is defined by its *hue* (its name, such as red or blue), its *value* (lightness or darkness), and its *saturation* or *intensity* (the purity of the color, such as the difference between fire-engine red and dull brick red). If you are not confident about the terms you want to use, check the glossary in an introductory textbook for that discipline. Generally, the definitions you find will be clear and concise.

10. Proofread Thoroughly

It is almost impossible for most writers to proofread their own work. We zoom ahead, overlooking missing words or grammatical errors. Grammar and spell-check programs can help, but the corrections they offer are not always appropriate, and real problems are often missed. So, get a meticulous friend to proofread your work, or read it aloud yourself. By reading aloud, the author is forced to slow down, and sentences that don't make sense tend to stand out like a sore thumb.

FINALLY

The train analogy in item 4 is useful, but imprecise. We are not running on a well-laid track and thus rarely know exactly where we are going

when we start to write. The writing process actually helps us clarify our thoughts and tell our story. As a result, it is important to allow time for reflection and revision. If you are disappointed with the grades you are receiving on your essays, try writing at least three or four drafts. A muddled thought often becomes clear when we return to it a day later. Most importantly, once our thoughts have been clarified through writing, each assignment becomes more memorable and more valuable.

GLOSSARY

analogical thinking. The use of analogies to explain, enhance, or clarify an idea

analogy. A comparison between two things, typically for the purpose of explanation or clarification

associative thinking. A means by which ideas within a given category can be expanded, or a means by which random ideas can be organized into categories

concept. A broad and often abstract idea

convergent thinking. An orderly, logical, and sequential thinking process that provides a step-by-step strategy for solving a clearly defined problem

creative thinking. A process that helps identify opportunities and develop potential solutions

creativity. The capacity to identify hidden potential and develop new connections

critical thinking. The objective analysis of facts or ideas in order to form a judgement

design thinking. A sequence of practices, initially used by designers, that helps people innovate effectively

divergent thinking. A nonlinear thinking strategy used to generate creative ideas by exploring many possible solutions

form. The tangible manifestation of an idea

hypothesis. A proposition put forth as a possible solution to a problem or an explanation of a situation

idea. A thought or suggestion as to a possible course of action

ideation. The process of developing ideas and forming concepts

implementation. The process of putting a plan into effect

innovation. A product, system, or service that improves on an existing product, system, or service

iteration. One version of a concept or idea

metaphor. A figure of speech that directly refers to one thing by mentioning another

pattern recognition. The ability to detect recurrent characteristics within a system or collection of data

process. A series of actions taken in order to achieve a particular end

rubric. A chart that helps us clearly assess the strengths and weaknesses in an object or idea

simile. A type of analogy that includes the words *like* or *as*

system. A group of interconnected elements that work together to achieve a common purpose

systems mapping. A way to visualize the many interconnections within a system

systems thinking. A strategy that challenges thinkers to look at interconnections among the parts in a problem in order to reach an informed and effective solution

technological or mechanical transfer. A strategy that explores ways in which a technique, technology, or adaptation used in one context can create fresh opportunities in another

thesis statement. The primary focus of a paper—the idea that the author will present and then support through various forms of evidence

NOTES

1. Hallie Levine, "Stick with It: 18 Fun Facts about the History of BAND-AID® Brand Adhesive Bandages," Johnson & Johnson, April 9, 2017, https://www.jnj.com/our-heritage/18-facts-about-the-history-of-band-aid-brand-adhesive-bandages/.

2. Amos Winter, "The Cheap All-Terrain Wheelchair," TEDx Boston 2012, accessed March 31, 2021, https://www.ted.com/talks/amos_winter_the_cheap_all_terrain_wheelchair/.

3. Edward Gorey, *Gashlycrumb Tinies, or, After the Outing* (New York: Simon & Schuster, 1963).

4. Peter Jakab, "Leonardo da Vinci and Flight," posted August 22, 2013, Smithsonian National Air and Space Museum, https://airandspace.si.edu/stories/editorial/leonardo-da-vinci-and-flight/.

5. "A History of the Airplane," Wright Brothers Aeroplane Co., accessed April 1, 2021, https://www.wright-brothers.org/History_Wing/History_of_the_Airplane/History_of_the_Airplane_Intro/History_of_the_Airplane_Intro.htm

FURTHER RESOURCES

BOOKS

Berger, Warren. *A More Beautiful Question: The Power of Inquiry to Spark Breakthrough Ideas*. New York: Bloomsbury, 2014.

Brown, Tim. *Change by Design: How Design Thinking Transforms Organizations and Inspires Innovation*. Rev. ed. New York: Harper Business, 2019.

Csikszentmihalyi, Mihaly. *Creativity: Flow and the Psychology of Discovery and Invention*. New York: HarperCollins, 1996.

Boyd, Drew, and Jacob Goldenberg. *Inside the Box: A Proven System of Creativity for Breakthrough Results*. New York: Simon & Schuster, 2013.

Grant, Adam. *Originals: How Non-conformists Move the World*. New York: Penguin Books, 2016.

Grant, Adam, *Think Again: The Power of Knowing What You Don't Know*. New York: Viking Books, 2021.

Heath, Dan. *Upstream: The Quest to Solve Problems Before They Happen*. New York: Avid Reader Press, 2020.

Keeley, Larry, Ryan Pikkel, Brian Quinn, and Helen Walters. *Ten Types of Innovation: The Discipline of Building Breakthroughs*. Hoboken, NJ: Wiley, 2013.

Kelley, Tom, with Jonathan Littman. *The Art of Innovation: Lessons in Creativity from IDEO, America's Leading Design Firm*. New York: Doubleday, 2001.

Kidder, David S. *The Startup Playbook: Secrets of the Fastest-Growing Startups from Their Founding Entrepreneurs*. San Francisco: Chronicle Books, 2012.

Robinson, Ken. *Out of Our Minds: Learning to Be Creative*. Rev. ed. Chichester, UK: Capstone, 2011.

Root-Bernstein, Robert, and Root-Bernstein, Michèle. *Sparks of Genius: The Thirteen Thinking Tools of the World's Most Creative People*. Boston: Mariner Books. 2001.

Seelig, Tina. *Creativity Rules: Get Ideas Out of Your Head and Into the World*. 1st paperback ed. New York: HarperCollins, 2017.

Sawyer, R. Keith. *Explaining Creativity: The Science of Human Innovation*. 2nd ed. New York: Oxford University Press, 2012.

Shekerjian, Denise. *Uncommon Genius: How Great Ideas Are Born*. New York: Penguin Books, 1991.

Tharp, Twyla, with Mark Reiter. *The Creative Habit: Learn It and Use It for Life: A Practical Guide*. 1st paperback ed. New York: Simon & Schuster, 2006.

PODCASTS

Raz, Guy. *How I Built This with Guy Raz*. National Public Radio. Podcast audio. https://www.npr.org/podcasts/510313/how-i-built-this.

> Interviewer Guy Raz discusses the inspiration, obstacles, and opportunities behind a wide range of successful companies.

Miller, Kara. *Innovation Hub*. WGBH and PRX. Podcast and radio show. http://blogs.wgbh.org/innovation-hub/.

> Host Kara Miller interviews "today's most creative thinkers, from authors to researchers to business leaders." This podcast "explores new avenues in education, science, medicine, transportation, and more."

Hu, Elise. *TED Talks Daily*. TED. Podcast. https://www.ted.com/about/programs-initiatives/ted-talks/ted-talks-audio.

> Every weekday, this feed brings listeners six- to eighteen-minute TED Talks in an audio format. It presents "thought-provoking ideas on every subject imaginable."

Zomorodi, Manoush. *TED Radio Hour*. TED. Podcast. https://www.ted.com/podcasts/ted-radio-hour.

> Using a single basic theme as a unifying framework, the host explores the emotions, insights, and discoveries that inspire innovation and make us human.

Anderson, Chris. *TED Interview*. TED. Podcast. https://www.ted.com/podcasts/ted-interview.

> "Head of TED Chris Anderson speaks with some of the world's most interesting people" to pursue big ideas in more depth than is possible in a brief TED talk.

Vedantam, Shankar. *Hidden Brain*. NPR. Podcast and radio show. https://www.npr.org/series/423302056/hidden-brain.

> "Using science and storytelling, Hidden Brain's host Shankar Vedantam reveals the unconscious patterns that drive human behavior, the biases that shape our choices, and the triggers that direct the course of our relationships."

SAMPLE ACADEMIC PROGRAMS, CENTERS, AND INSTITUTES

Please note that the following list is just a sample. New programs are developing all the time!

UNITED STATES OF AMERICA

Arizona State University, Tempe, Arizona
https://herbergerinstitute.asu.edu/degree-programs/creative-enterprise-and-cultural-leadership

"Creative enterprise and cultural leadership students are changemakers and innovators working toward more just and sustainable futures that connect art and design to society. The program has a particular emphasis on impact and place, looking at how art practice intersects with the social, political, economic, and other structures that shape communities. This cross-disciplinary, collaborative program merges theory and practice in arts management, civic practice, creative placemaking, leadership and the management of innovation in the expanded creative fields."

Carnegie Mellon University, Pittsburgh, Pennsylvania
https://ideate.cmu.edu/

"IDeATe, the Integrative Design, Arts, and Technology network at Carnegie Mellon, offers undergraduate minors and courses in Game Design, Animation & Special Effects, Media Design, Sonic Arts, Design for Learning, Innovation & Entrepreneurship, Intelligent Environments, Physical Computing, and Soft Technologies. These areas merge technology and creativity and provide learning opportunities for interdisciplinary collaboration."

Creative Education Foundation, Scituate, Massachusetts
http://www.creativeeducationfoundation.org/

The Creative Education Foundation is a nonprofit membership organization comprised of leaders in the fields of creativity theory and practice. "The mission of the Creative Education Foundation is to spark personal and professional transformation by empowering people with the skill set, tool set, and mindset of deliberate creativity."

College of Creative Studies, University of California, Santa Barbara, California
https://www.ccs.ucsb.edu/

"Since 1967, the College of Creative Studies (CCS) has offered a small intellectual community of committed undergraduate students and faculty set within a major research university. CCS students and their faculty advisors work together to design a study plan that encourages students to take risks, to explore, and to develop their passion."

International Center for Studies in Creativity, Buffalo State University, Buffalo, New York
https://creativity.buffalostate.edu/

"ICSC is the first program in the world to teach the science of creativity at a graduate level: Our Graduate Certificate program includes six courses that focus on creative process, facilitation, assessment, training, theory, and leadership. With an additional four courses, including a master's project or thesis, students can complete a Master of Science degree in creativity and change leadership."

Stanford University d.school, Palo Alto, California
https://dschool.stanford.edu/about

"The d.school helps people develop their creative abilities. It's a place, a community, and a mindset. . . . We build on methods from across the field of design to create learning experiences that help people unlock their creative potential and apply it to the world."

Torrance Center for Creativity and Talent Development, University of Georgia, Athens, Georgia

https://coe.uga.edu/directory/torrance-center

"The Torrance Center for Creativity and Talent Development is a service, research, and instructional center based in UGA's Mary Frances Early College of Education. The focus of the Torrance Center is in the identification and development of creative potential across the lifespan. . . . The overarching goals of the Torrance Center are to investigate, implement, and evaluate techniques for enhancing creative thinking across domains of human enterprise and to increase creativity literacy in the local, state, national, and international community."

CANADA

Atlantic Centre for Creativity, University of New Brunswick, Fredericton, New Brunswick

http://www.atlanticcentreforcreativity.com/

"Atlantic Centre for Creativity was established to support and advance research, teaching, and learning. It promotes all forms of creativity, including problem solving, innovation, and entrepreneurship." The center's very extensive website includes interviews, research papers, podcasts, and many other resources.

Faculty of Creative and Critical Studies, University of British Columbia, Kelowna, British Columbia

https://fccs.ok.ubc.ca/

"FCCS is a community engaged faculty whose work combines traditional scholarly and hands-on skills with contemporary technologies. We are a meeting place for passionate thinkers, researchers, makers, and artists committed to a university experience that builds connections between global, local, settler, and indigenous communities."

Taylor Institute, University of Calgary, Alberta

https://taylorinstitute.ucalgary.ca/about/mission-vision

"We aim to create opportunities to link networks of educational leaders, faculty, staff and students and to encourage the flow of knowledge between these groups. To ensure accessibility and inclusivity, we offer varied programs, workshops, and events on diverse topics for a range of experience levels. We create multiple points of entry for beginners and then provide ongoing activities to develop expertise, community, and leadership."

Centre for Imagination in Research, Culture & Education, Faculty of Education, Simon Fraser University, British Columbia

http://www.circesfu.ca/

The Centre for Imagination in Research, Culture & Education "is an international organization dedicated to imagination in all its varied forms. While we have deep roots, interest, and involvement in the field of education, we branch into a range of other fields including leadership, business, STEM/STEAM, and the arts." Their mission is "growing engaged minds: imagining and making better worlds."

School of Creative Industries | Ryerson University, Toronto, Ontario

https://www.ryerson.ca/creativeindustries/future-students/

The Creative Industries program is "designed to give you the skills you will need to be successful in the creative workplace. Your studies will have a dual focus that will enable you to explore and understand the Creative Industries as both creative process and commercial activity. . . . Core courses will develop your competencies in communication, digital technology, critical thinking, research design, collaboration and teamwork . . ."

Centre for Humanities Research and Collaboration, Laurentian University, Sudbury, Ontario

https://laurentian.ca/research/centres/chrc

The Centre for Humanities Research and Collaboration (CHRC) facilitates research and creative projects that bring the academic excellence and artistic capability of the humanities to both theoretical study and practical application. CHRC promotes the engagement of higher learning and cultural development by collaborating with community arts groups and by working in the media arts.

INDEX

ABOUT THE AUTHOR

Mary Stewart is an artist, author, and educator. Her work has been shown in over one hundred exhibitions nationally and internationally, and early in her career, she received two Pennsylvania Council on the Arts grants for collaborative choreography. She is the author of *Launching the Imagination: A Comprehensive Guide to Basic Design*, a best-selling design textbook. Stewart received a Southeastern College Art Association Excellence in Teaching Award in 2010, the Foundations in Art: Theory and Education Master Educator award in 2009, and the National Council of Arts Administrators Award of Distinction in 2008. From 2019 to 2021, she worked with Atlantic Centre for Creativity in Canada as part of her second Fulbright Fellowship.

ABOUT THE AUTHOR